enchanted
Adult Coloring Book

Discover the Healing Power of Coloring Pages

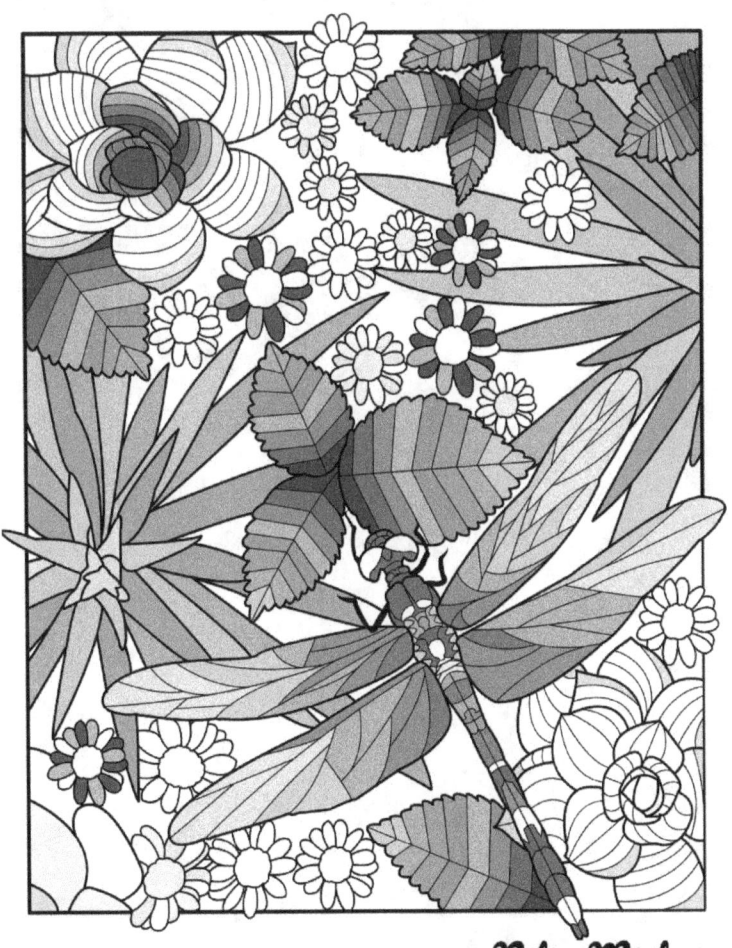

Nitin Mistry

Copyright © 2019 All Rights Reserved.
Nitin Mistry
First Printing, 2019

All rights reserved. No part of this publication may be reproduced, stored in a retrieval system, or transmitted, in any form or any means, electronic, mechanical, photocopying, recording or otherwise, without prior written permission in accordance with the provisions of the Copyright Act 1956 (as amended). Any person or persons who do any unauthorised act in relation to this publication may be liable to criminal prosecution and civil claims or damages.

ISBN: 9781693010941
Printed in the
United States of America

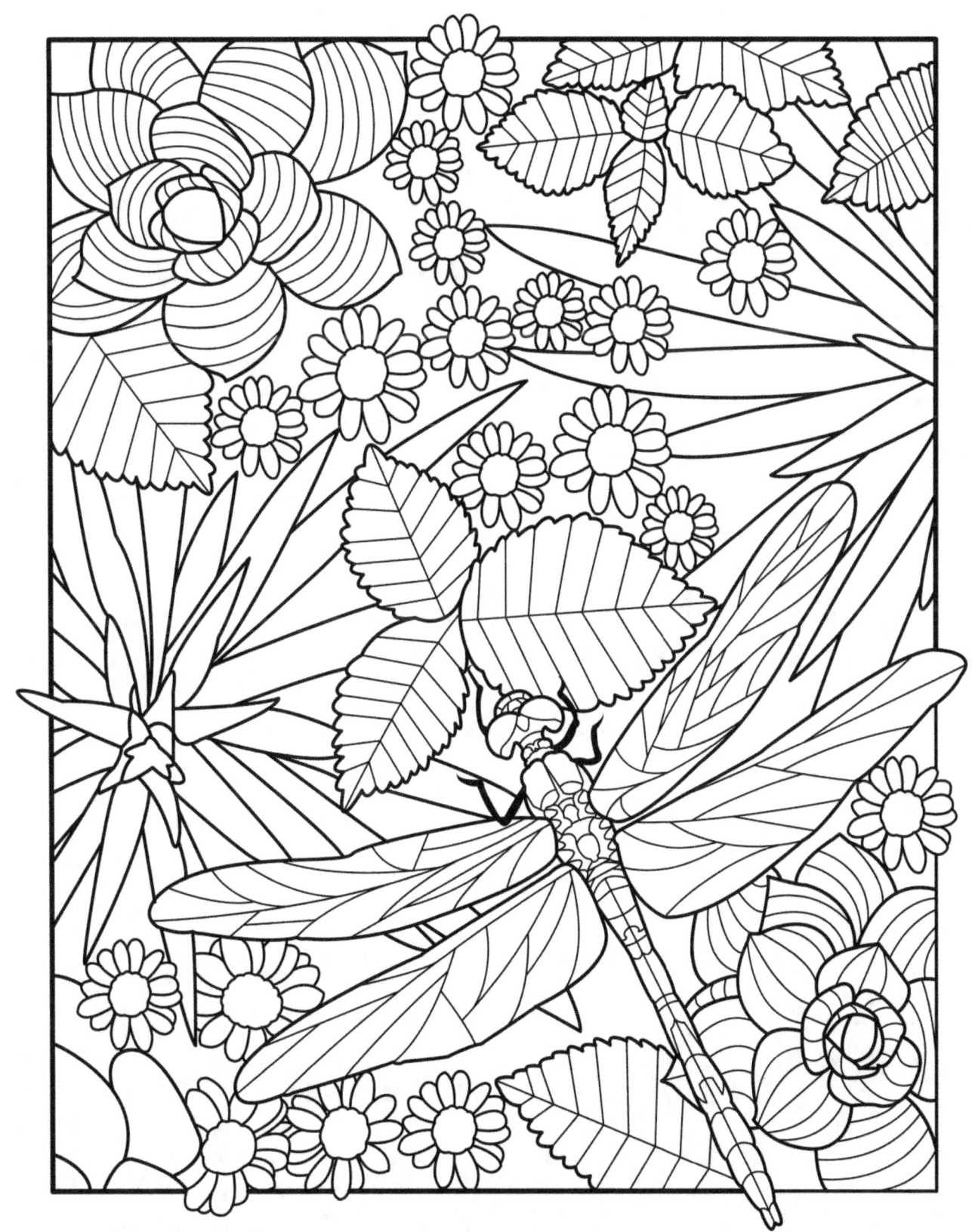

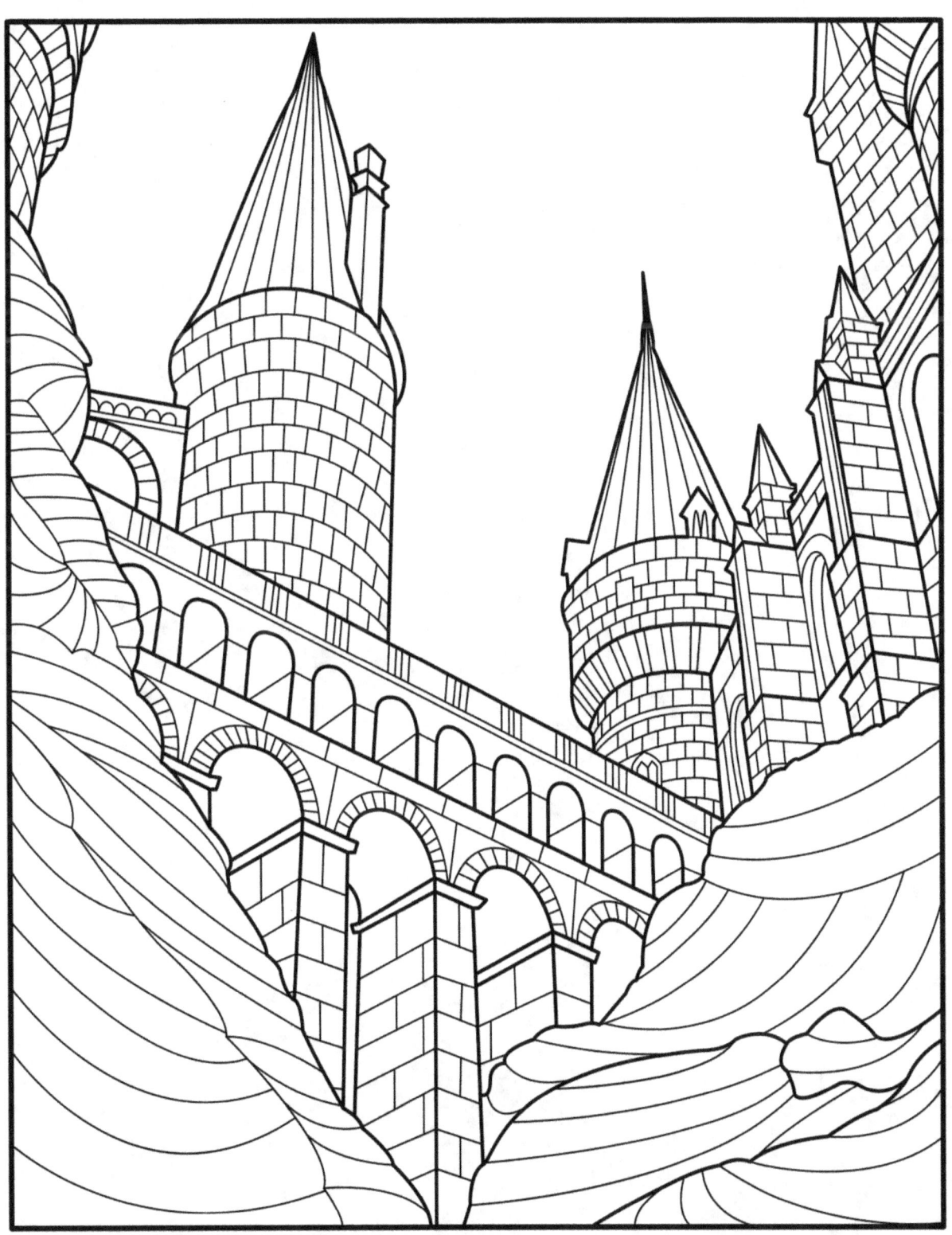

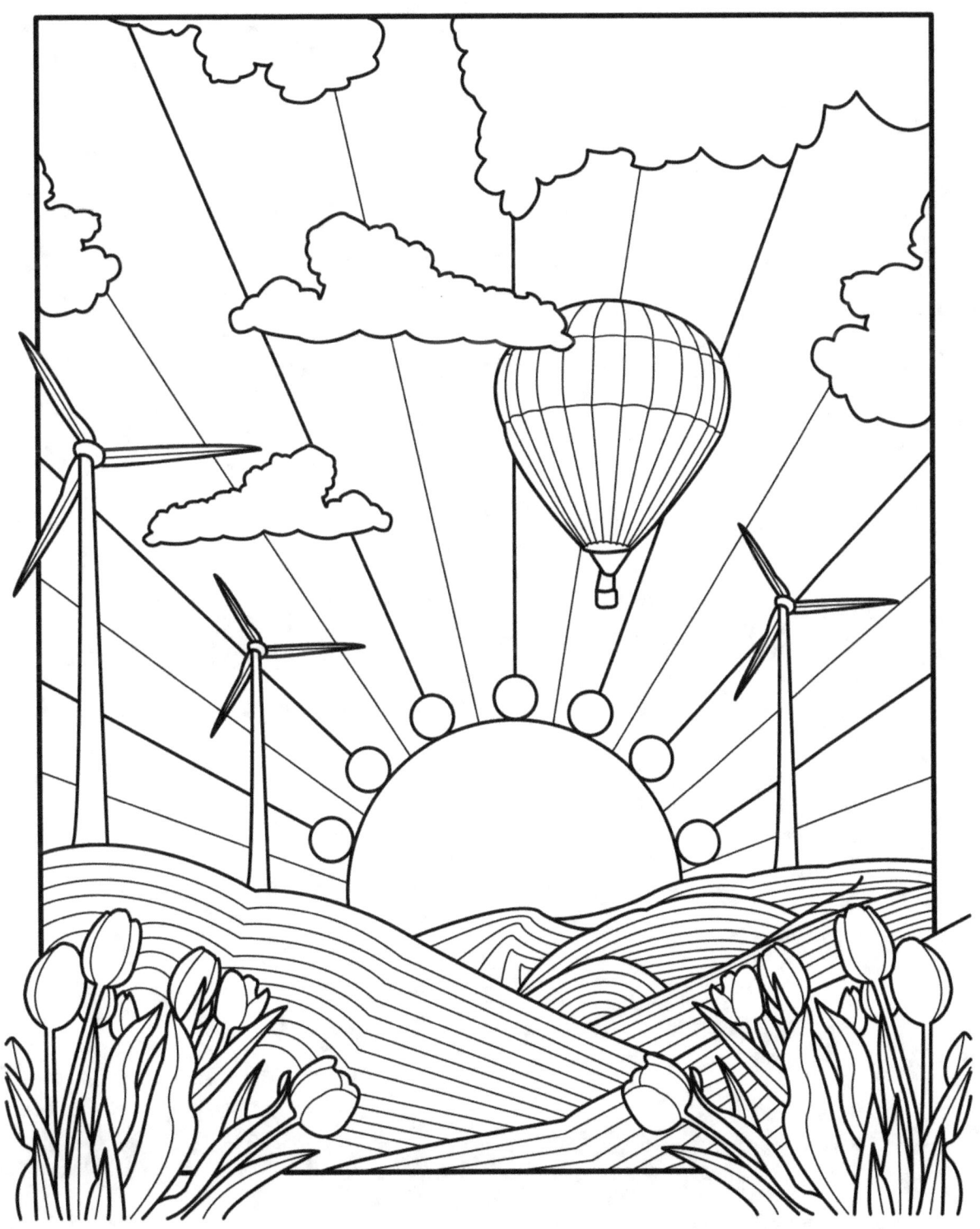

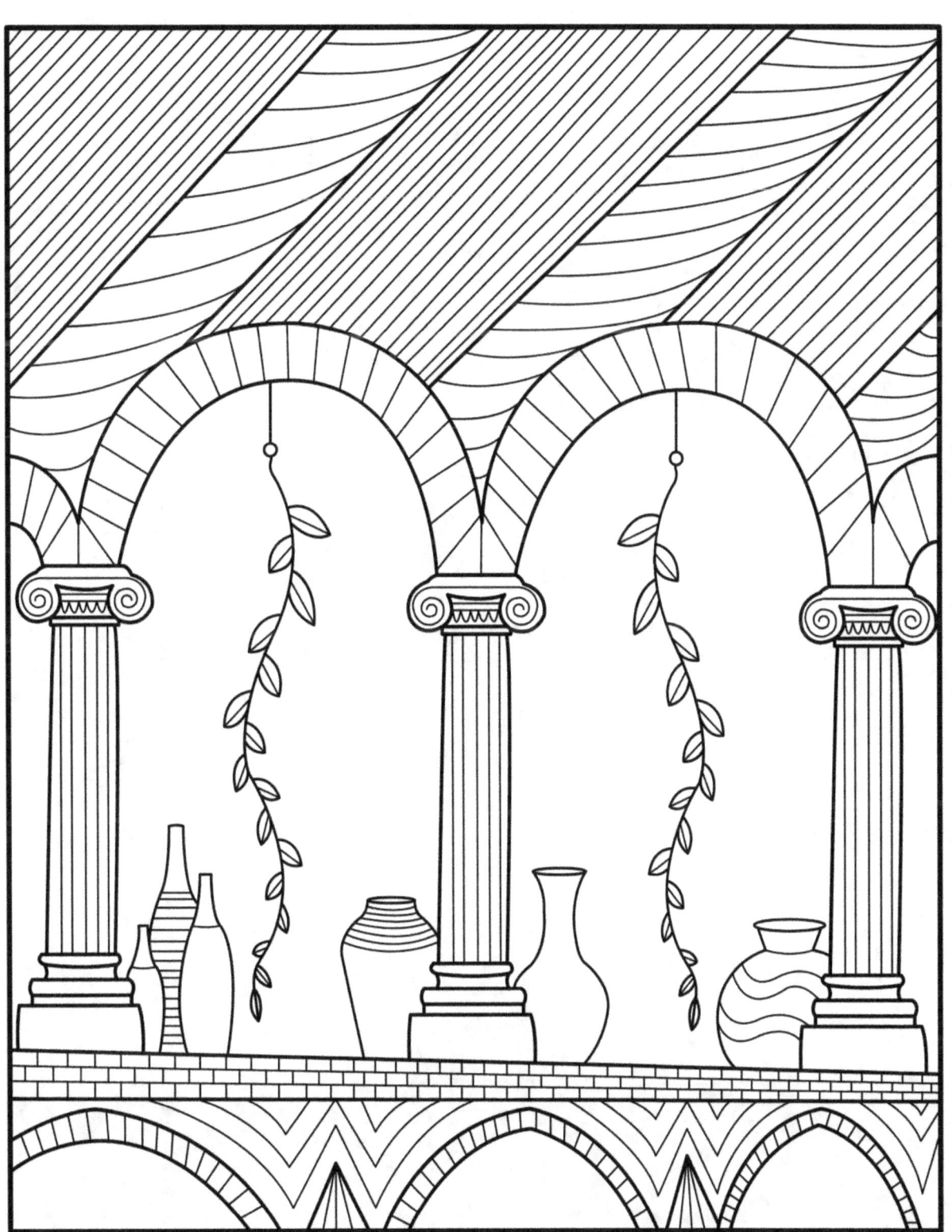

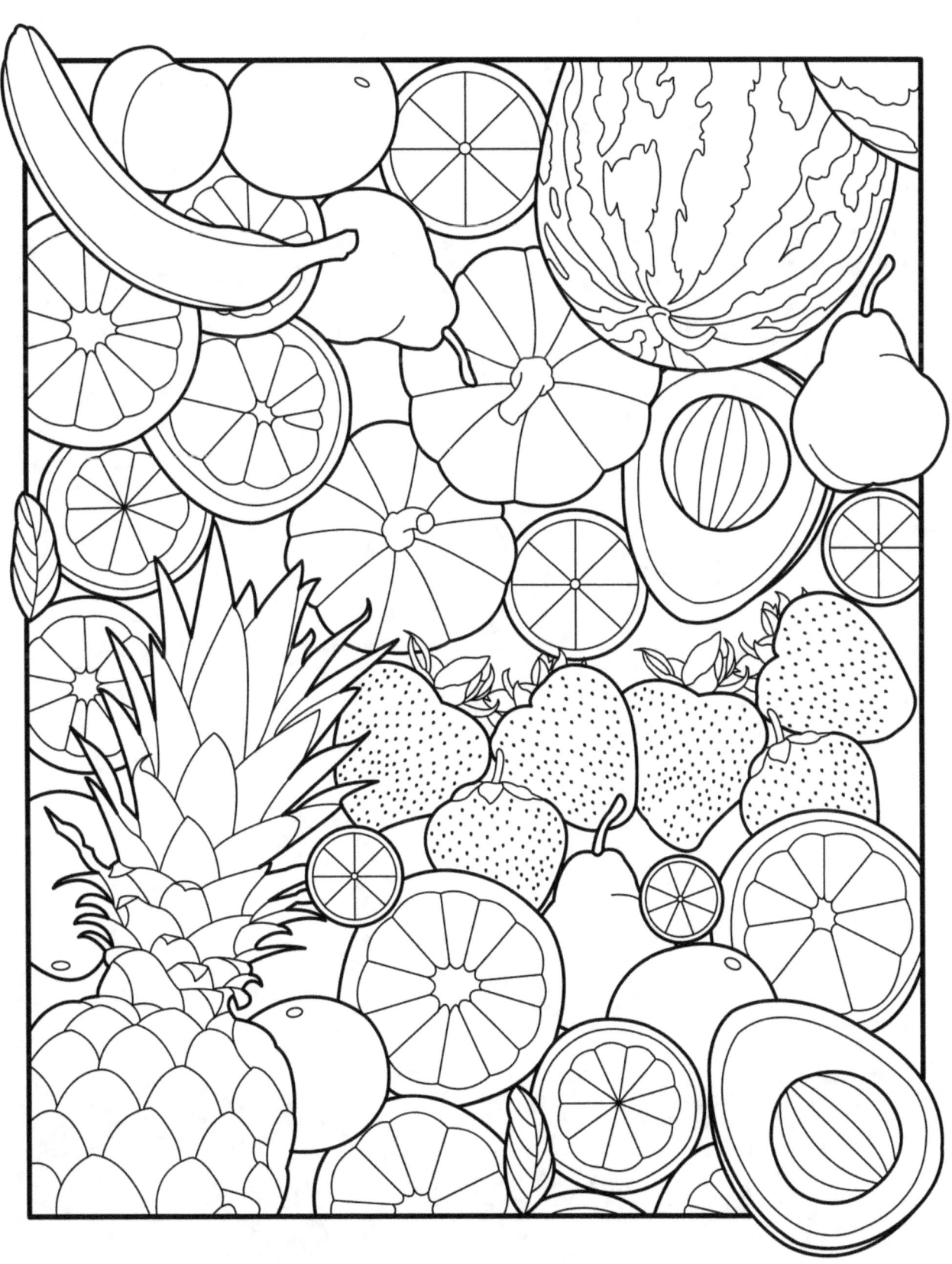

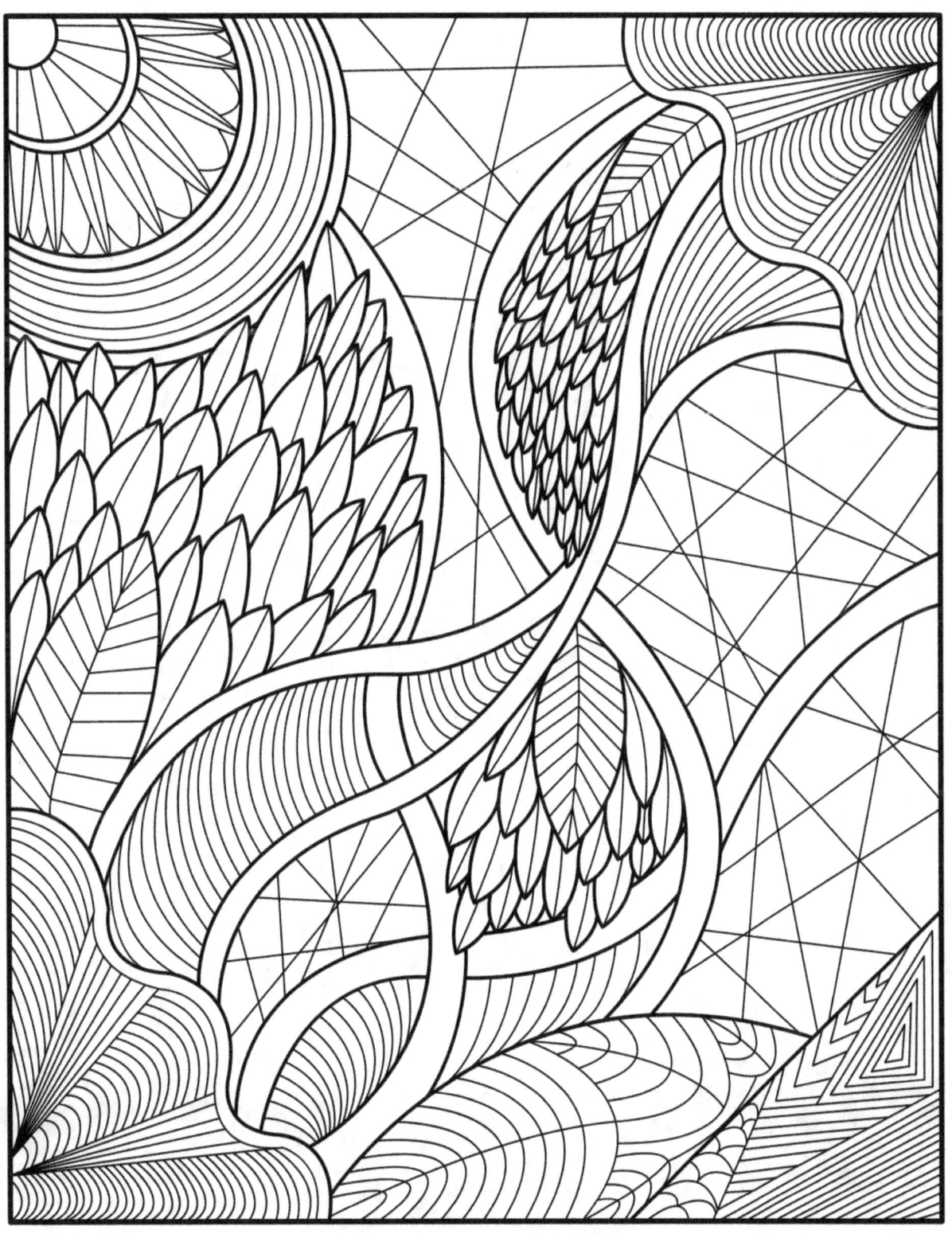

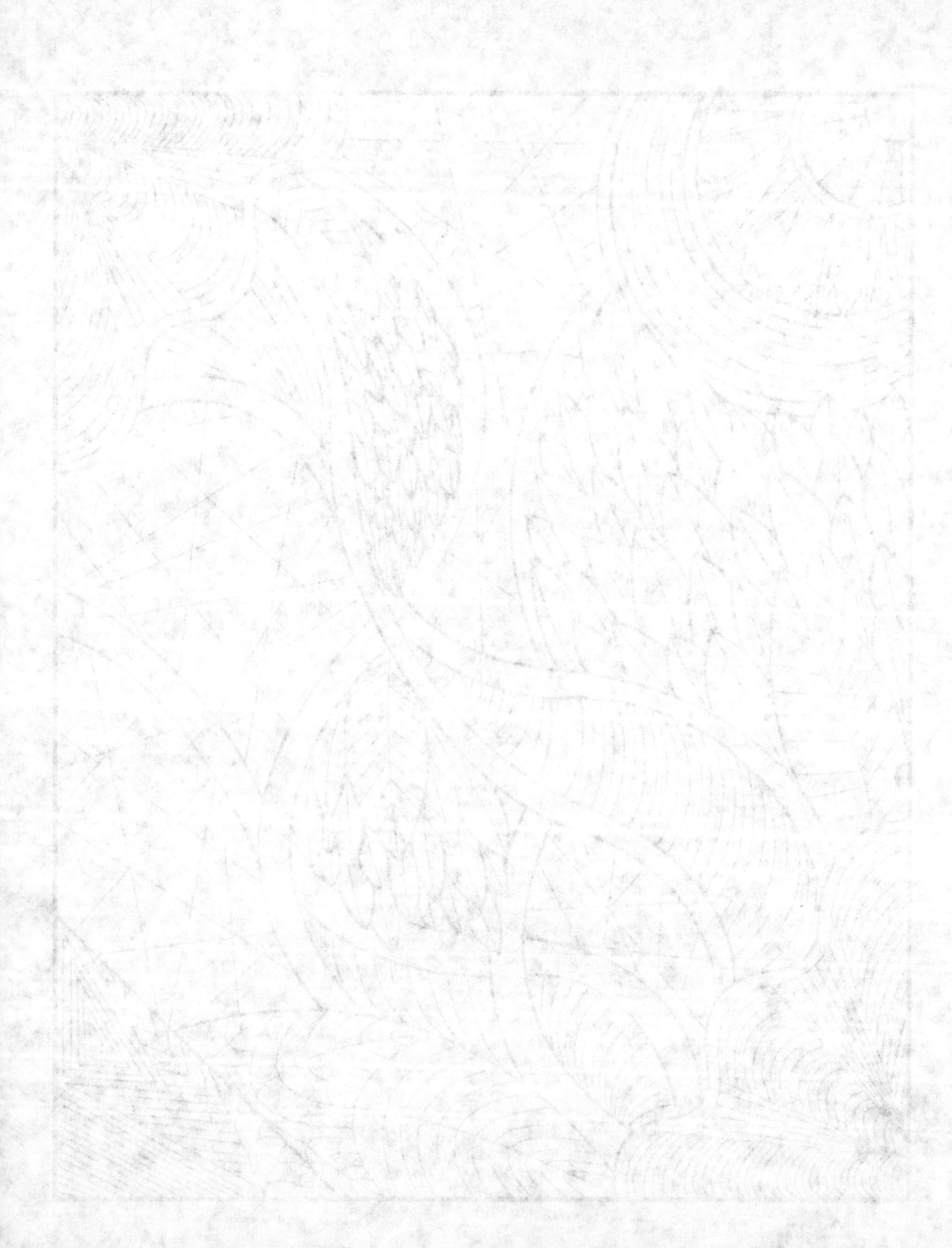

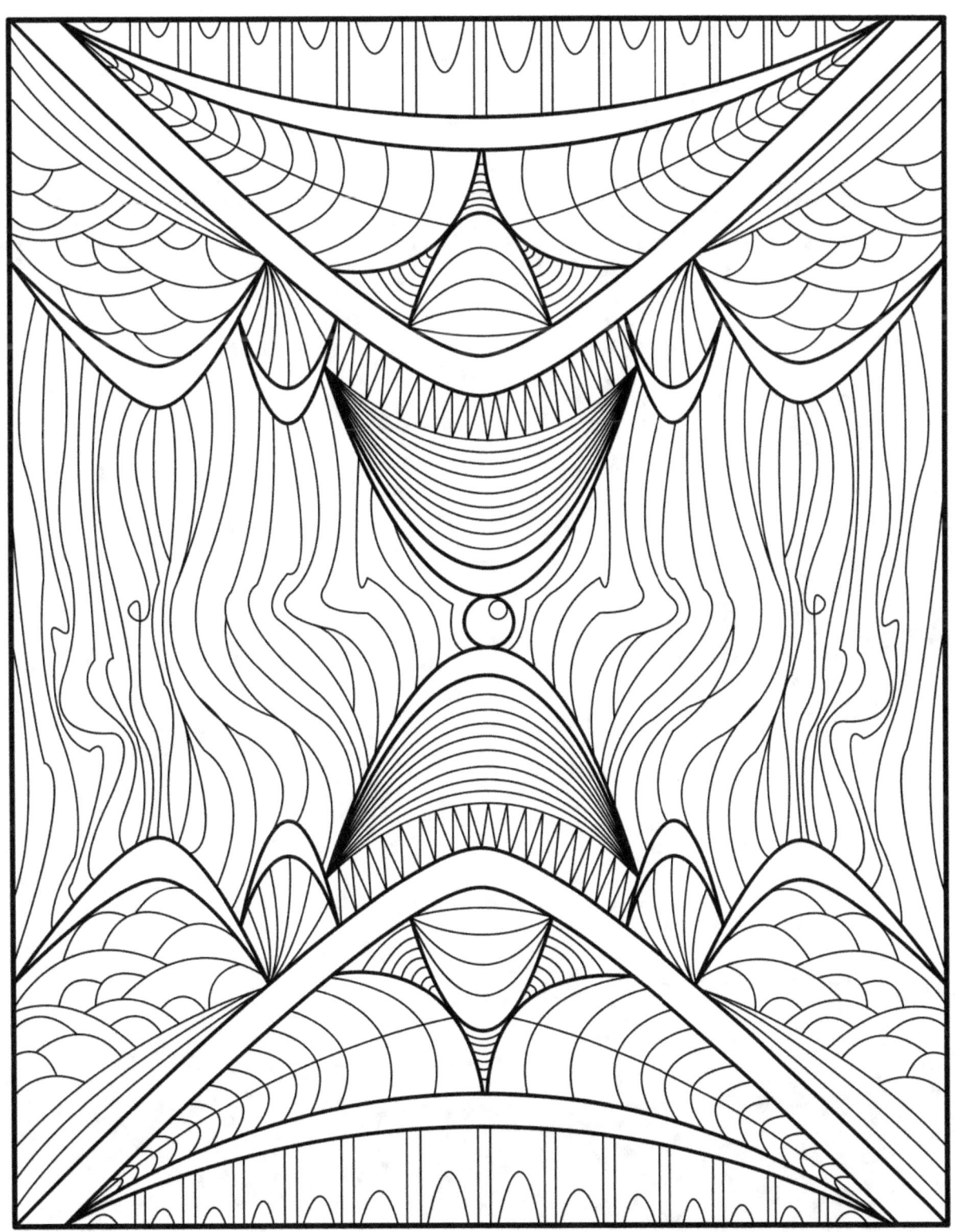

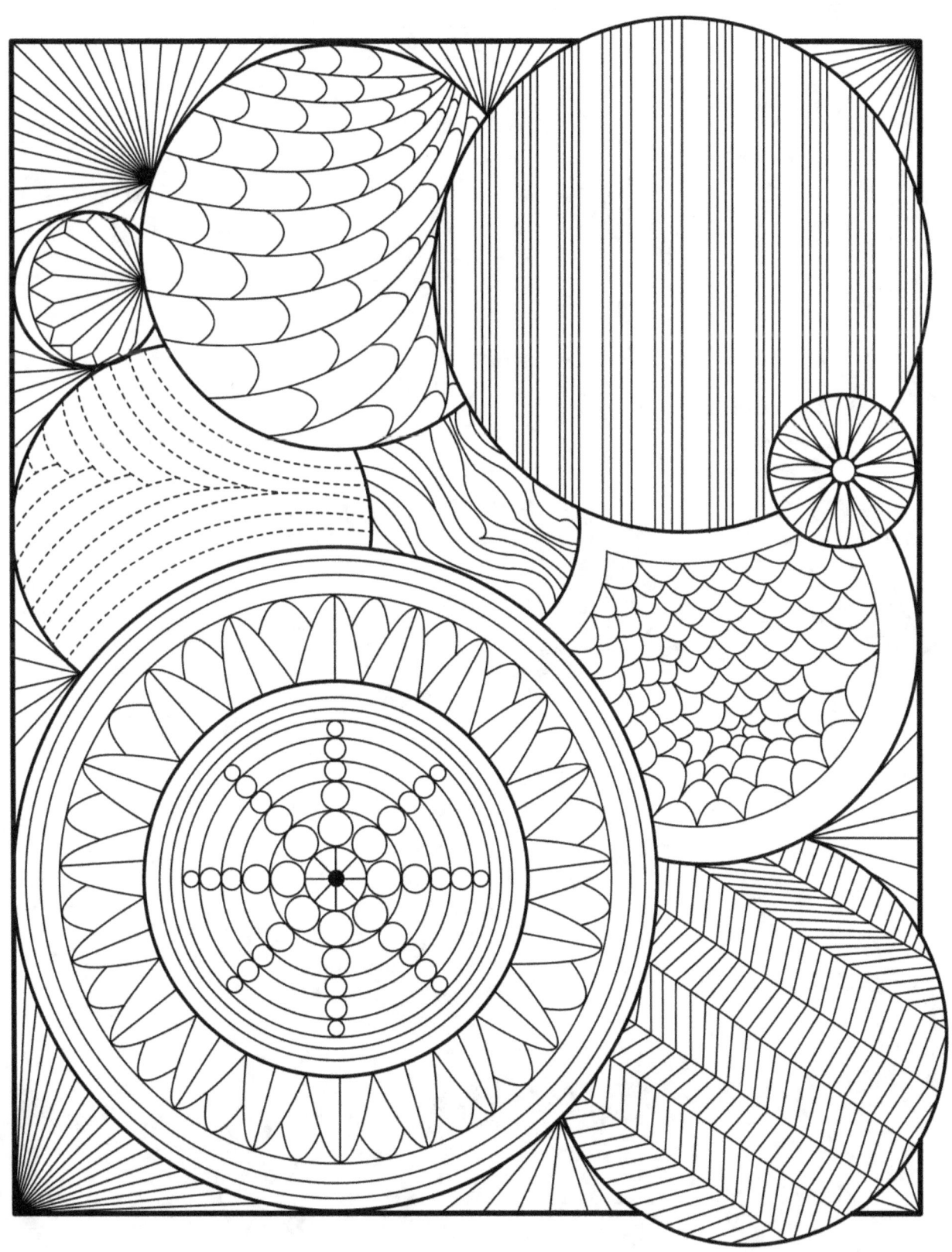

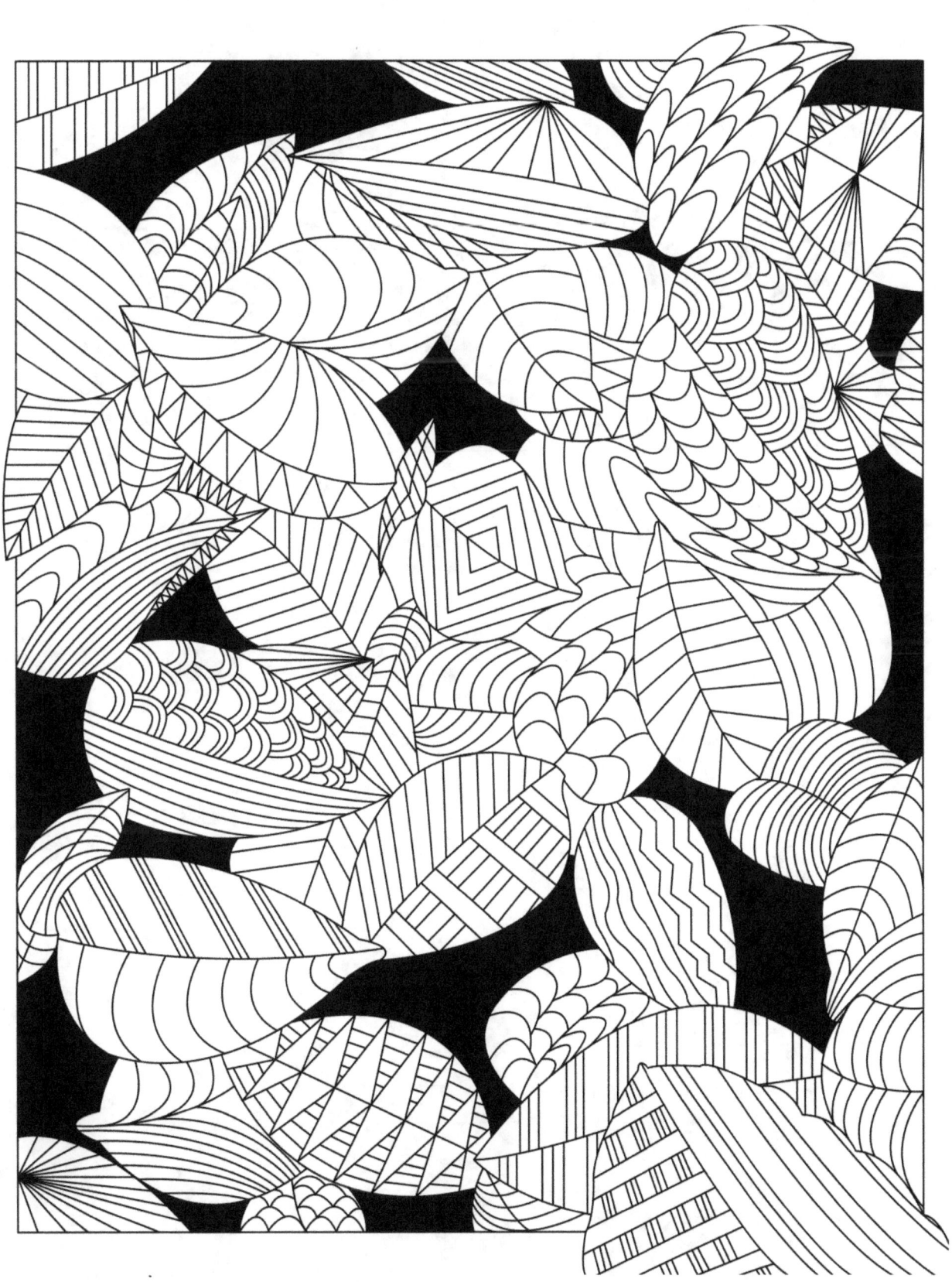

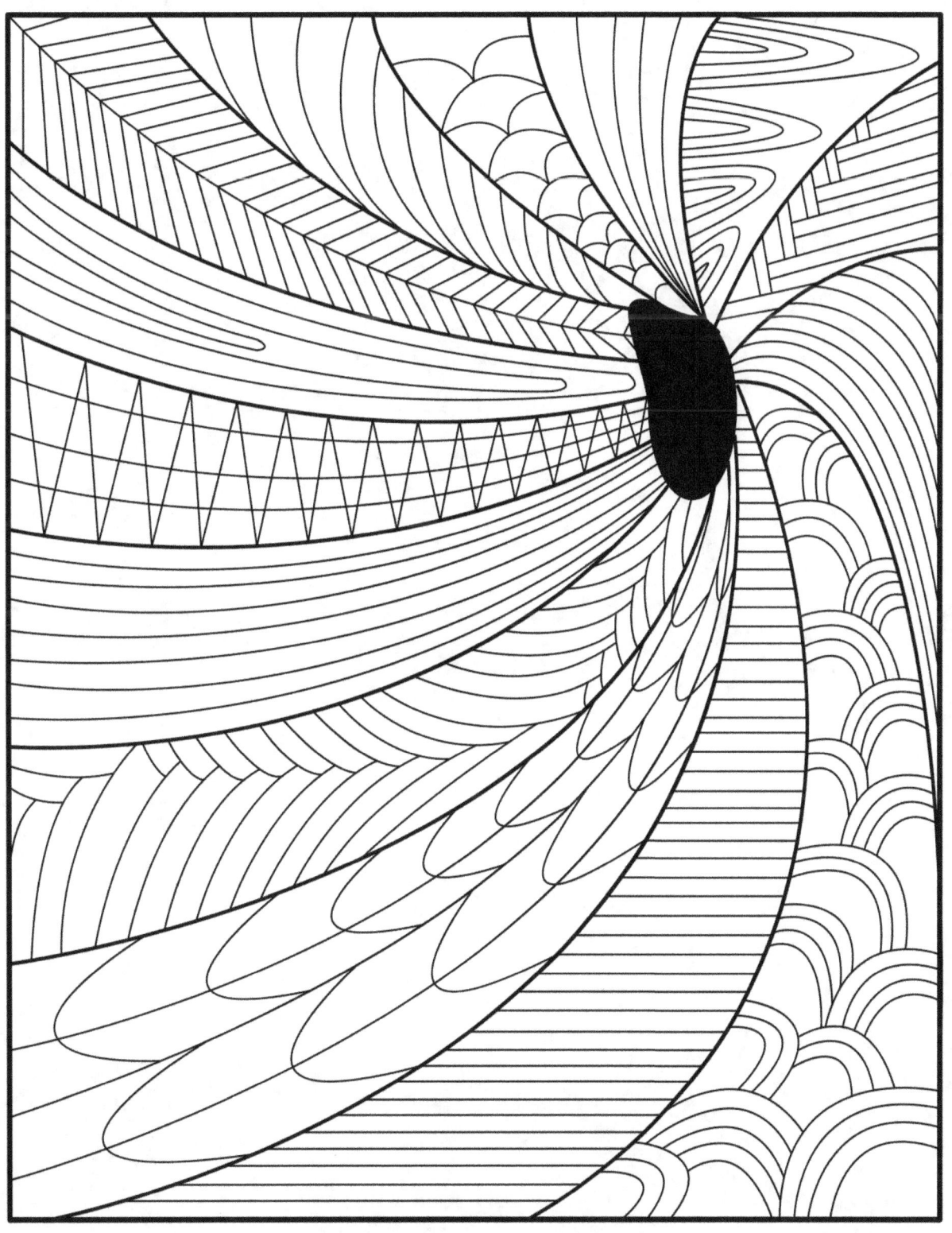

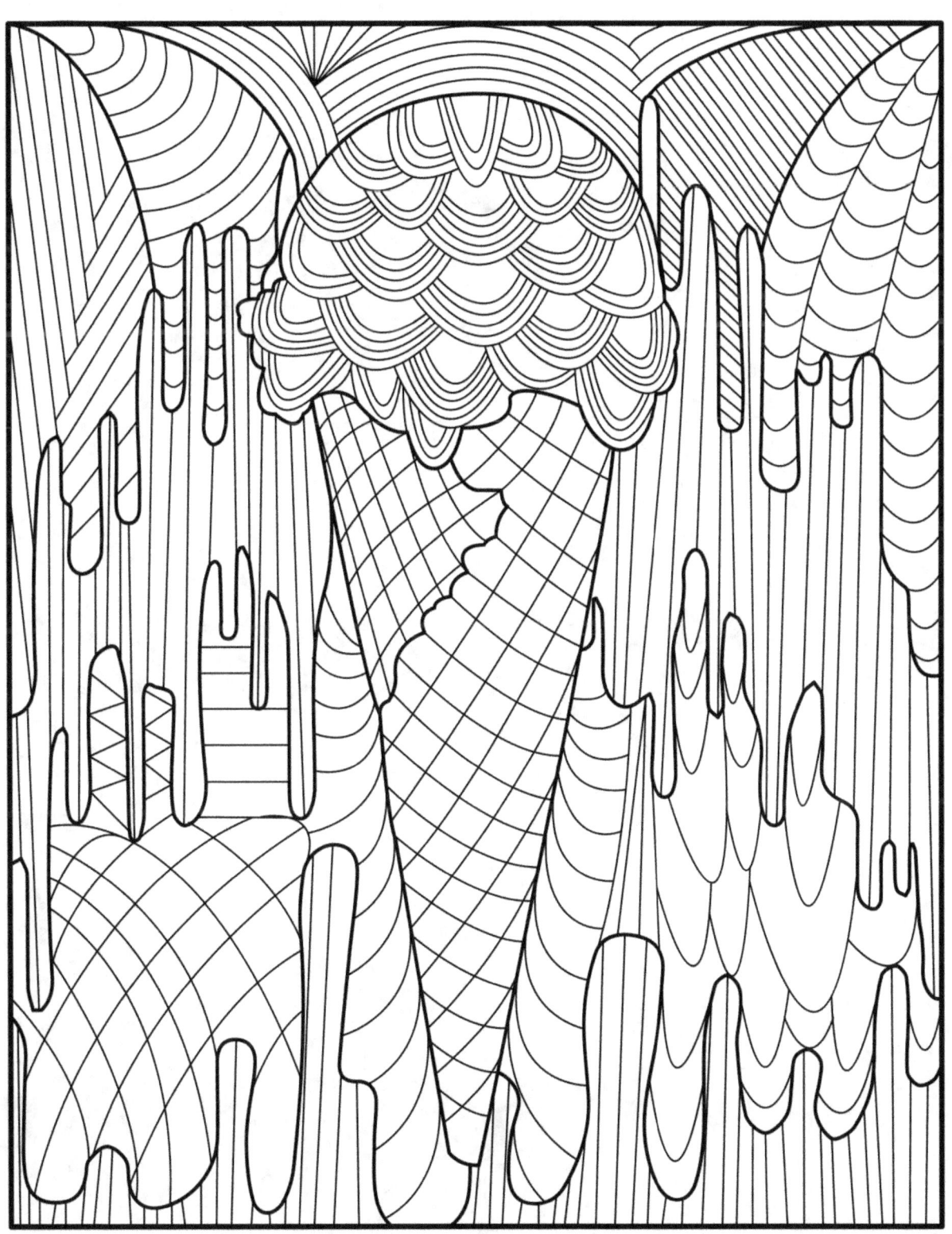

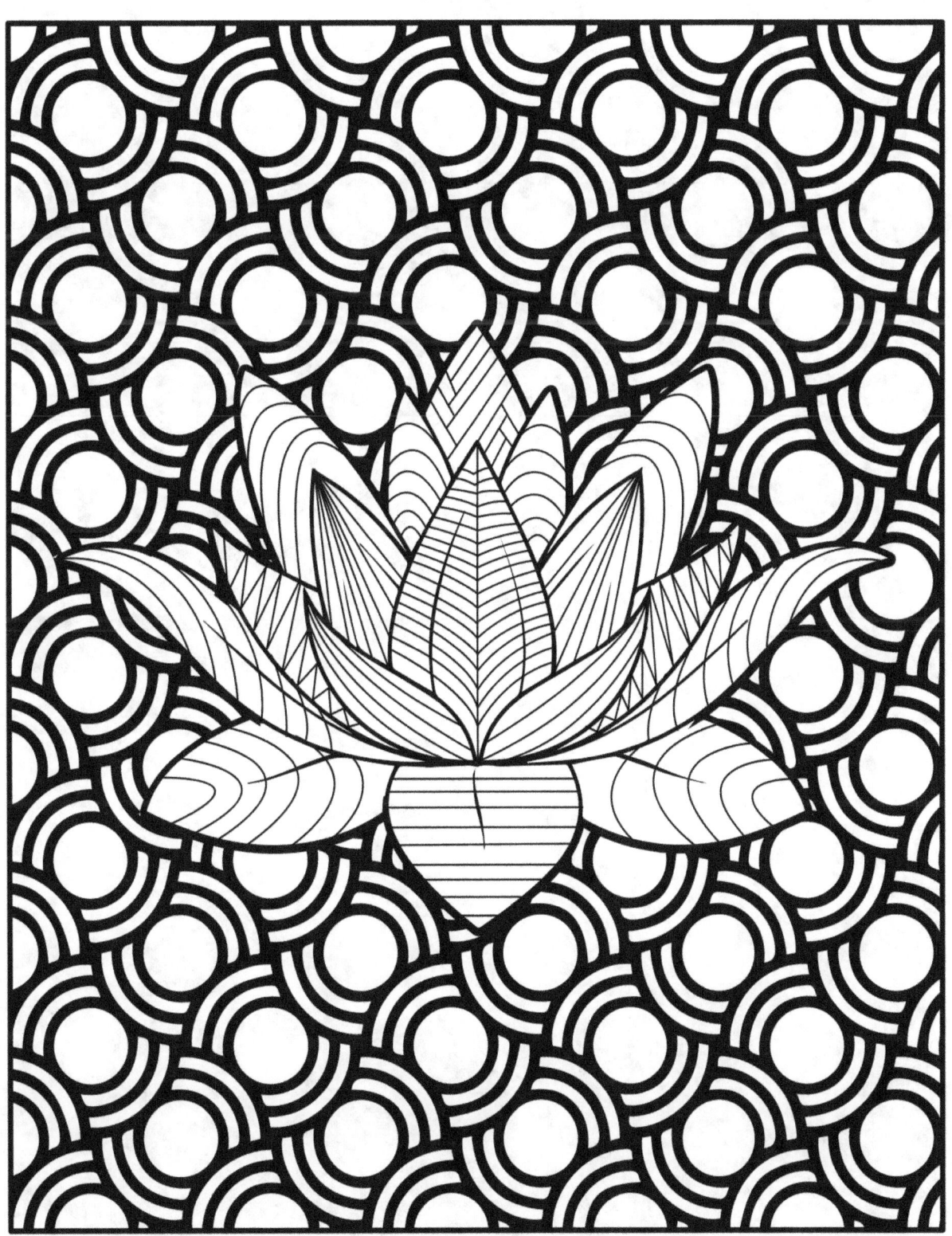

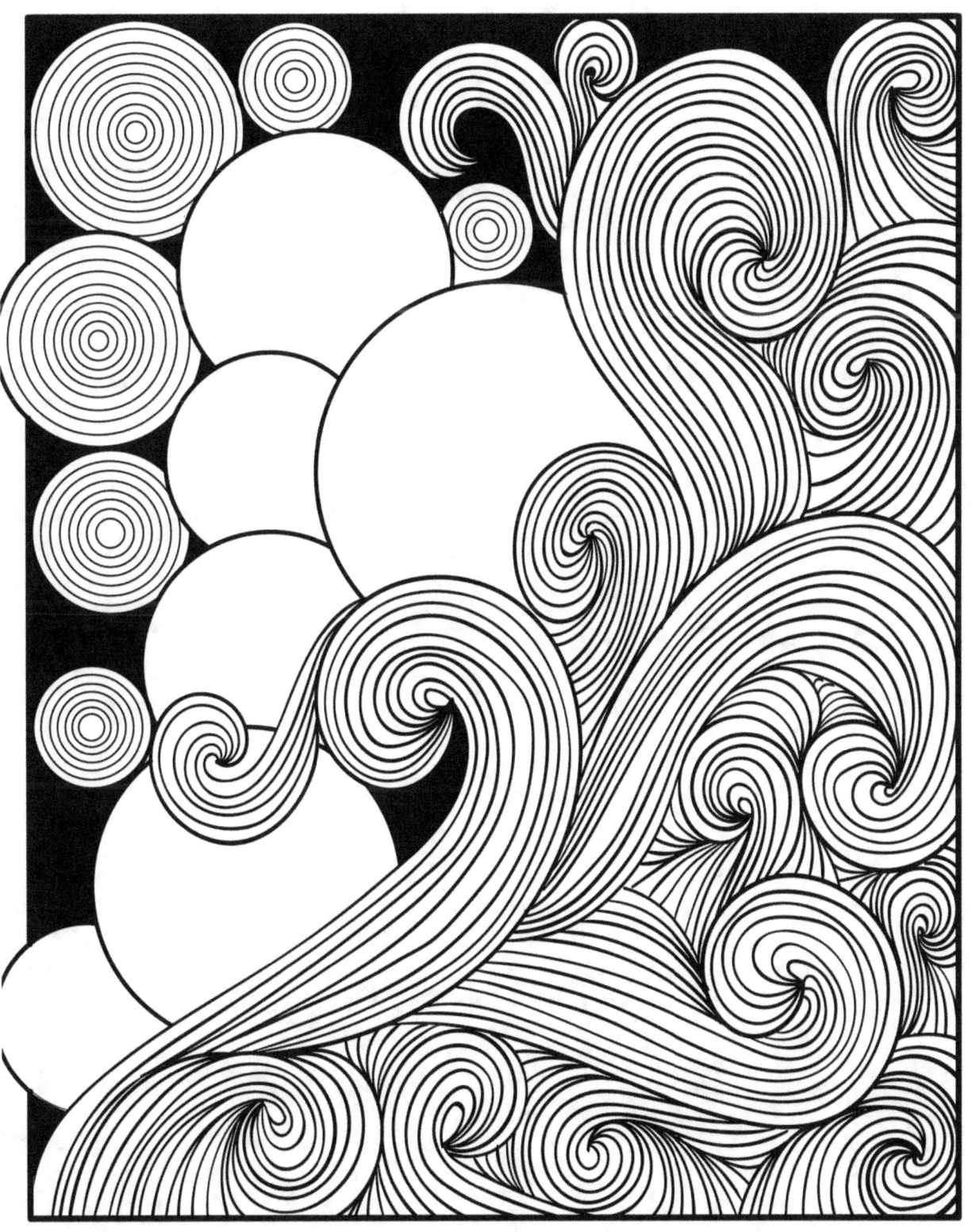

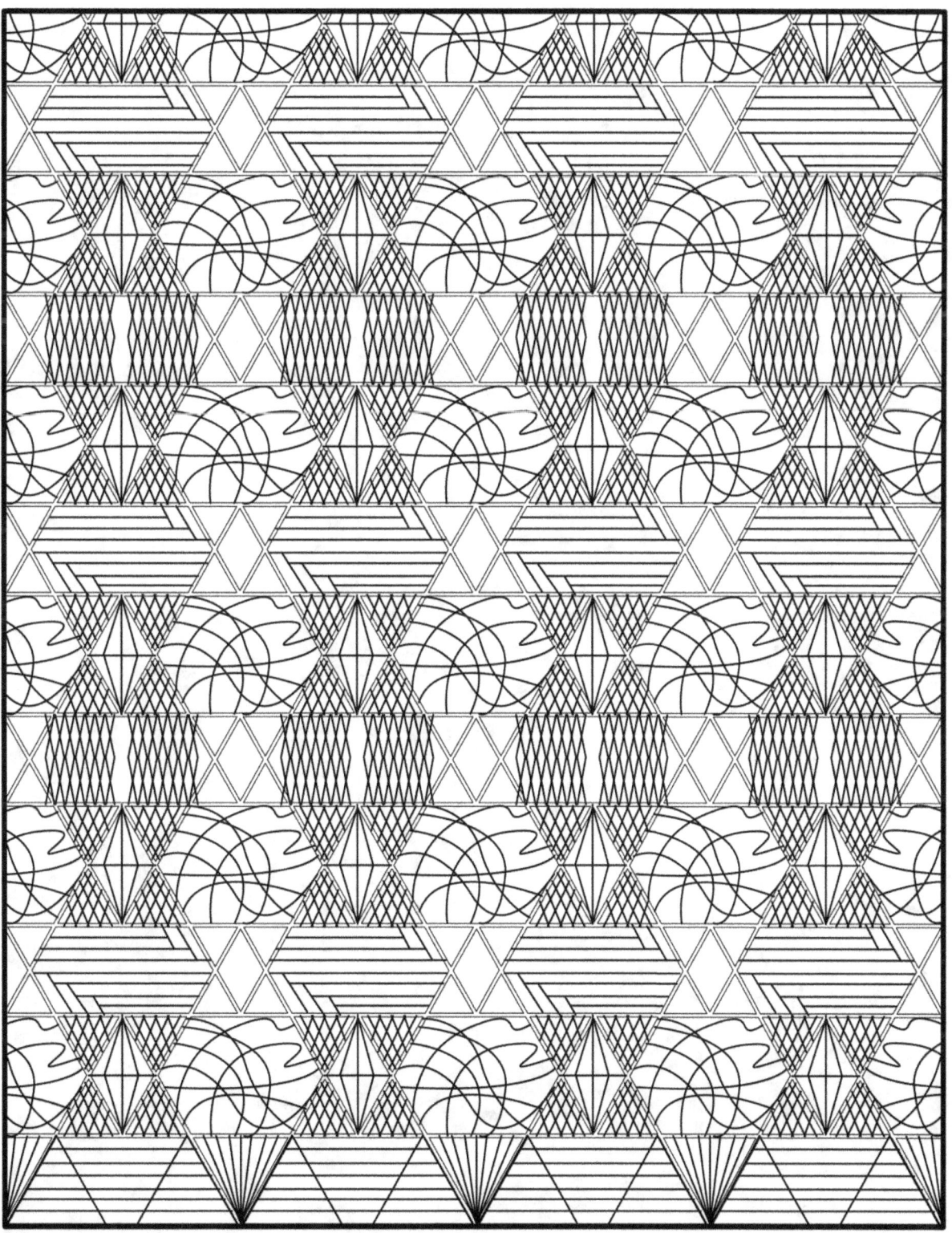

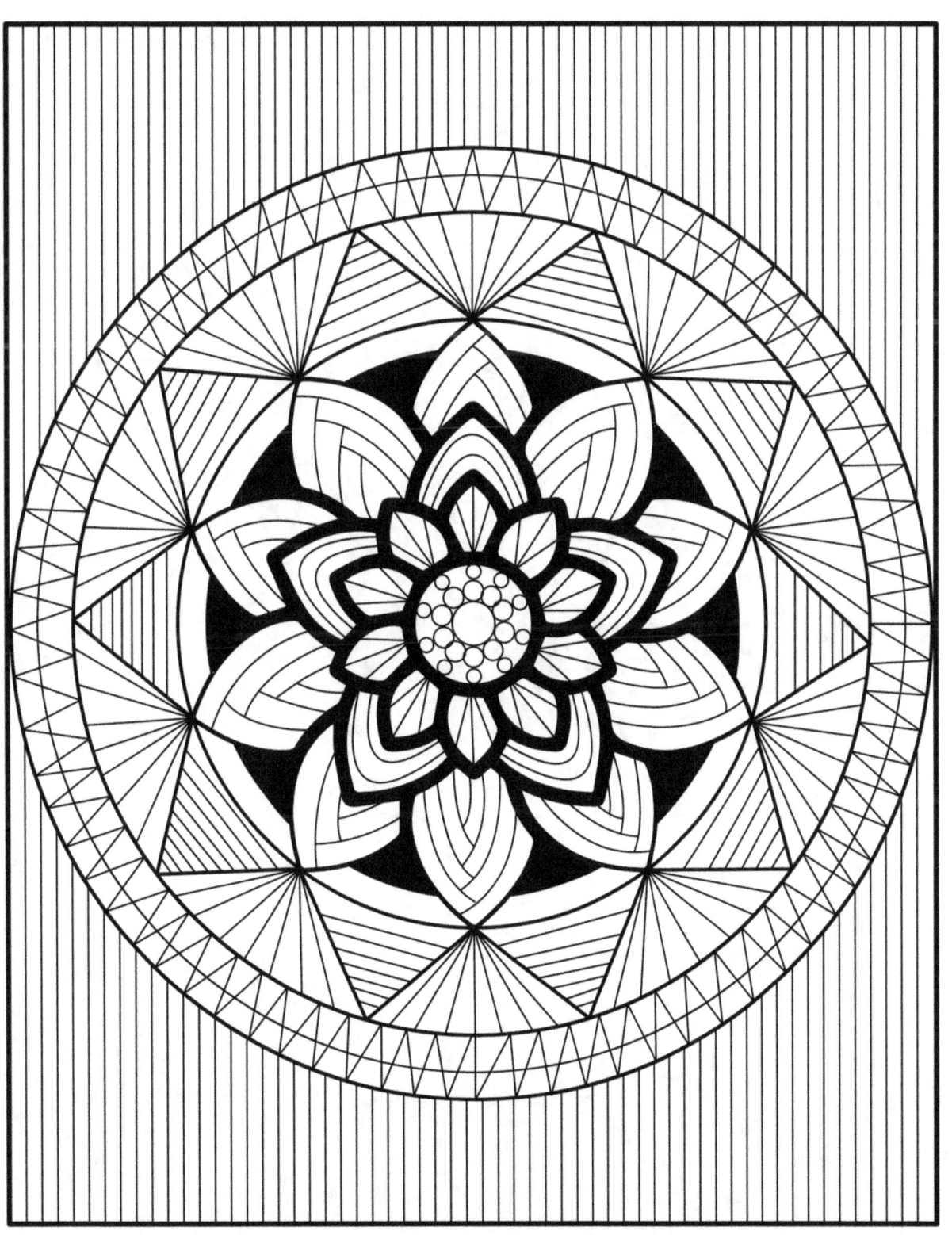

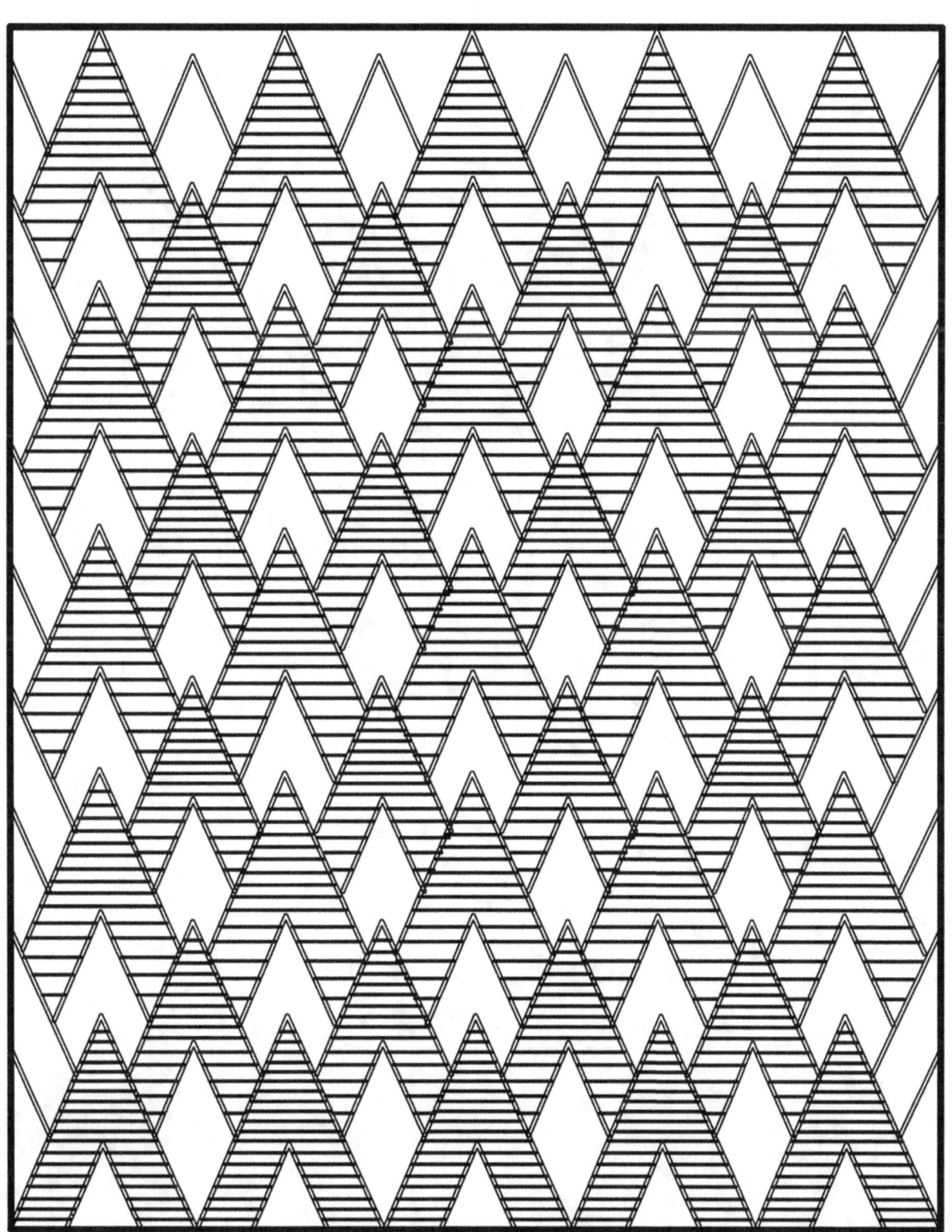

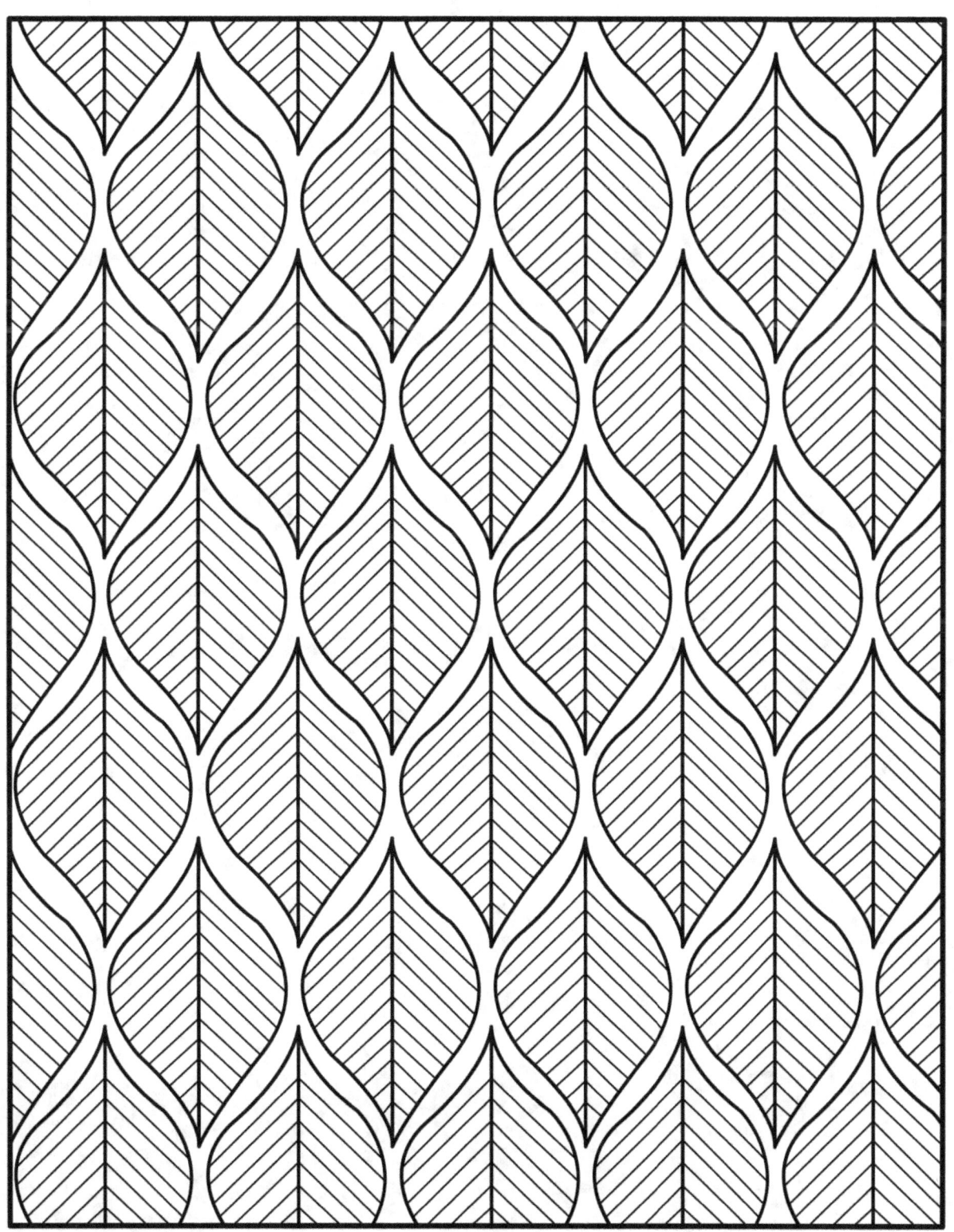

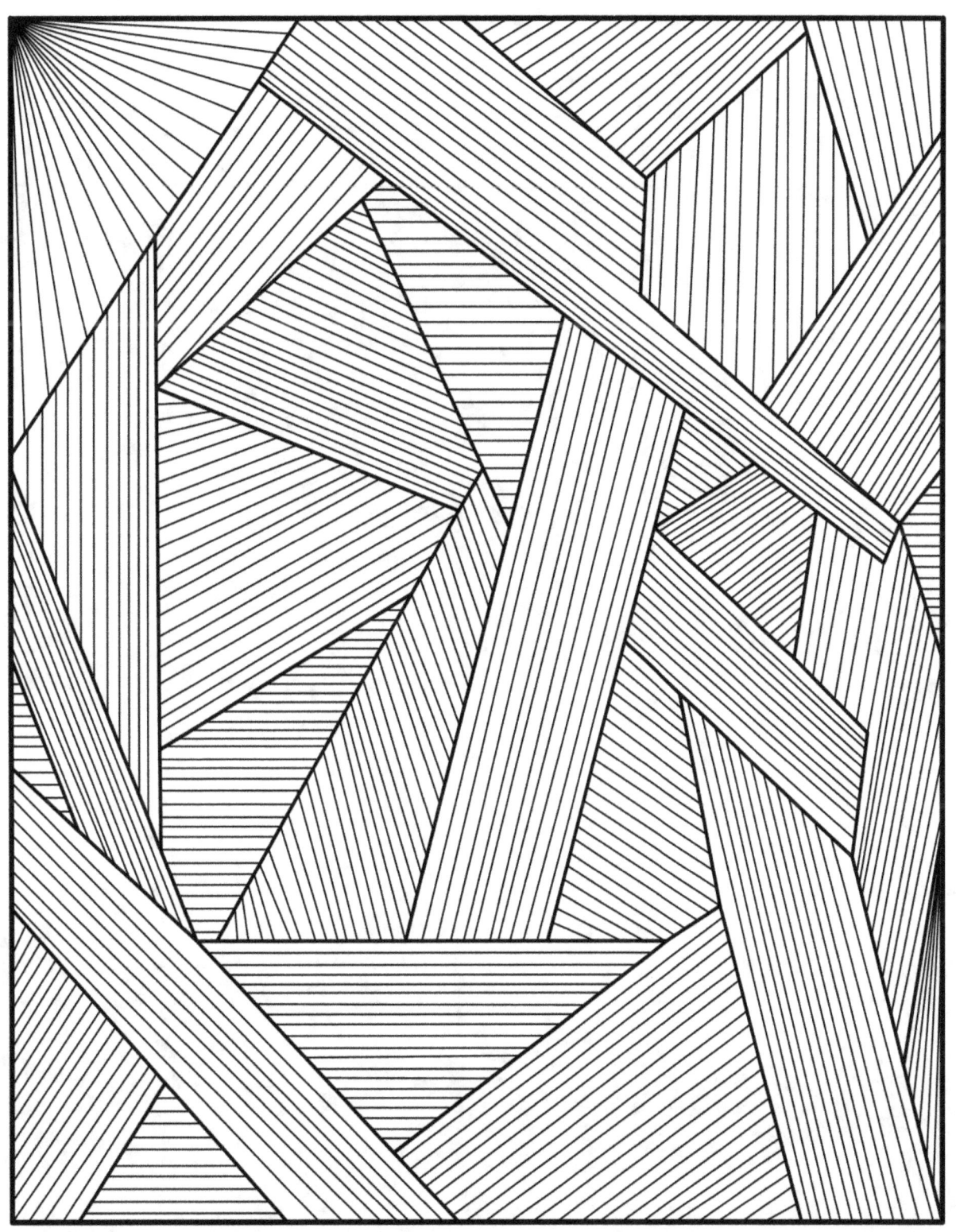

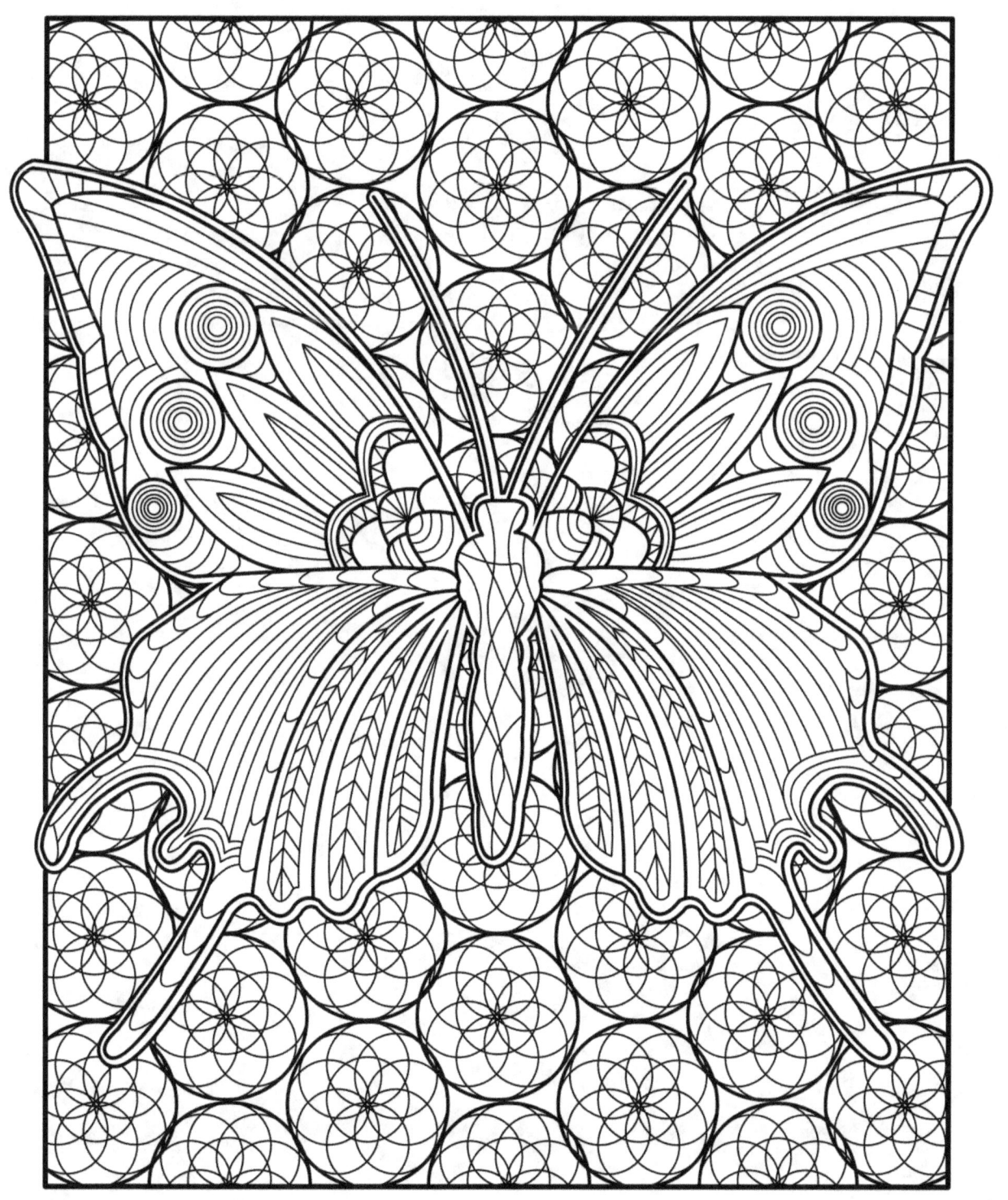

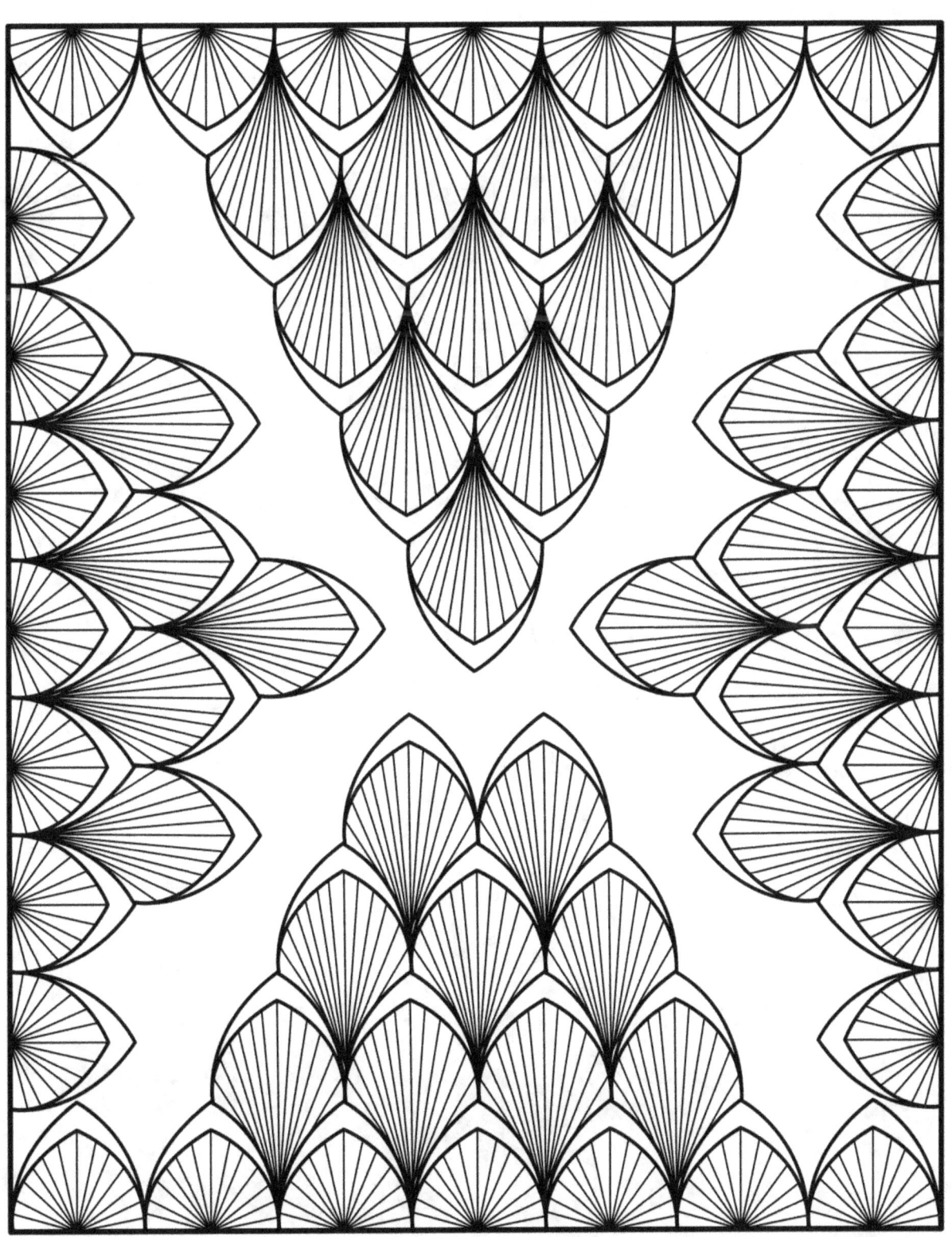

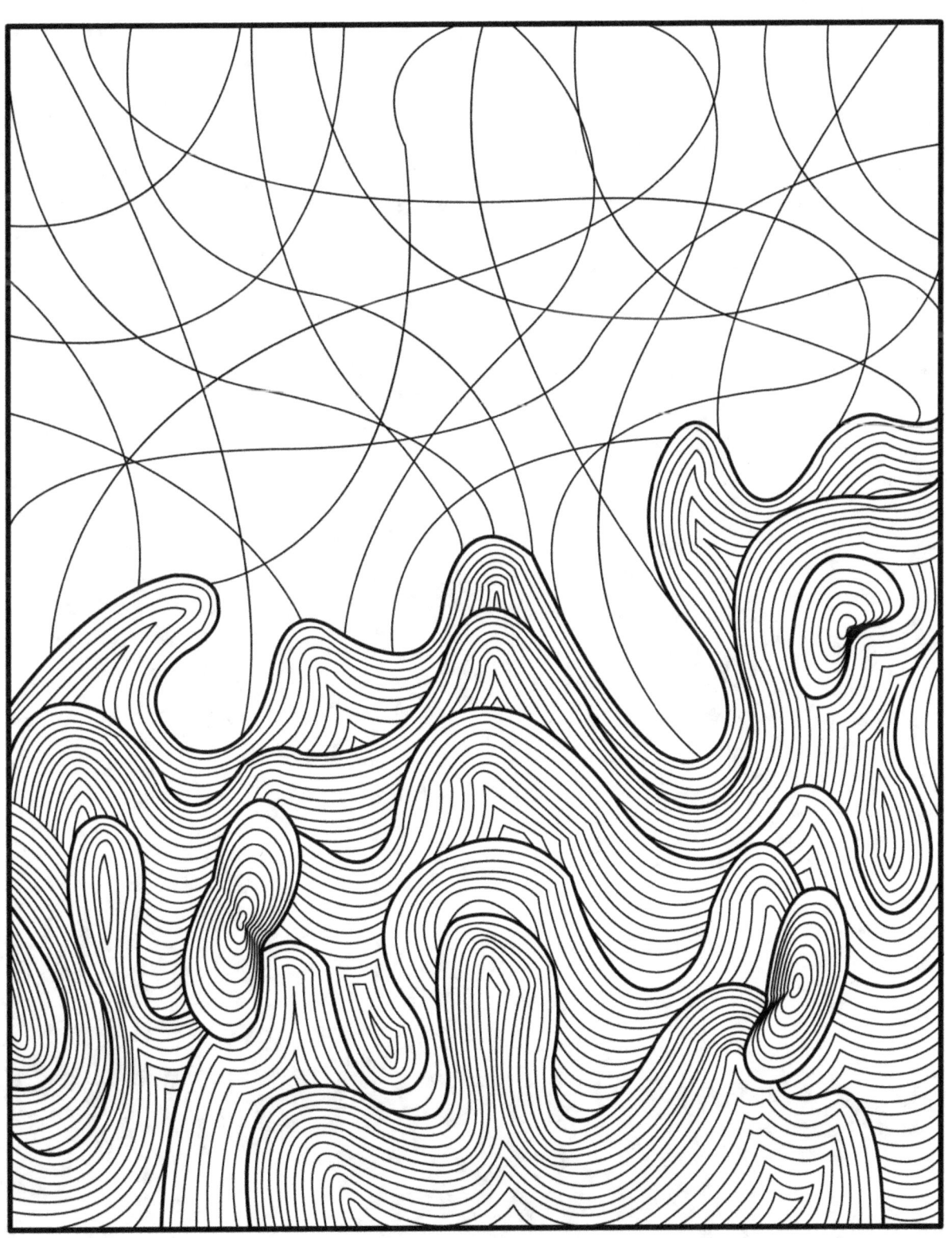

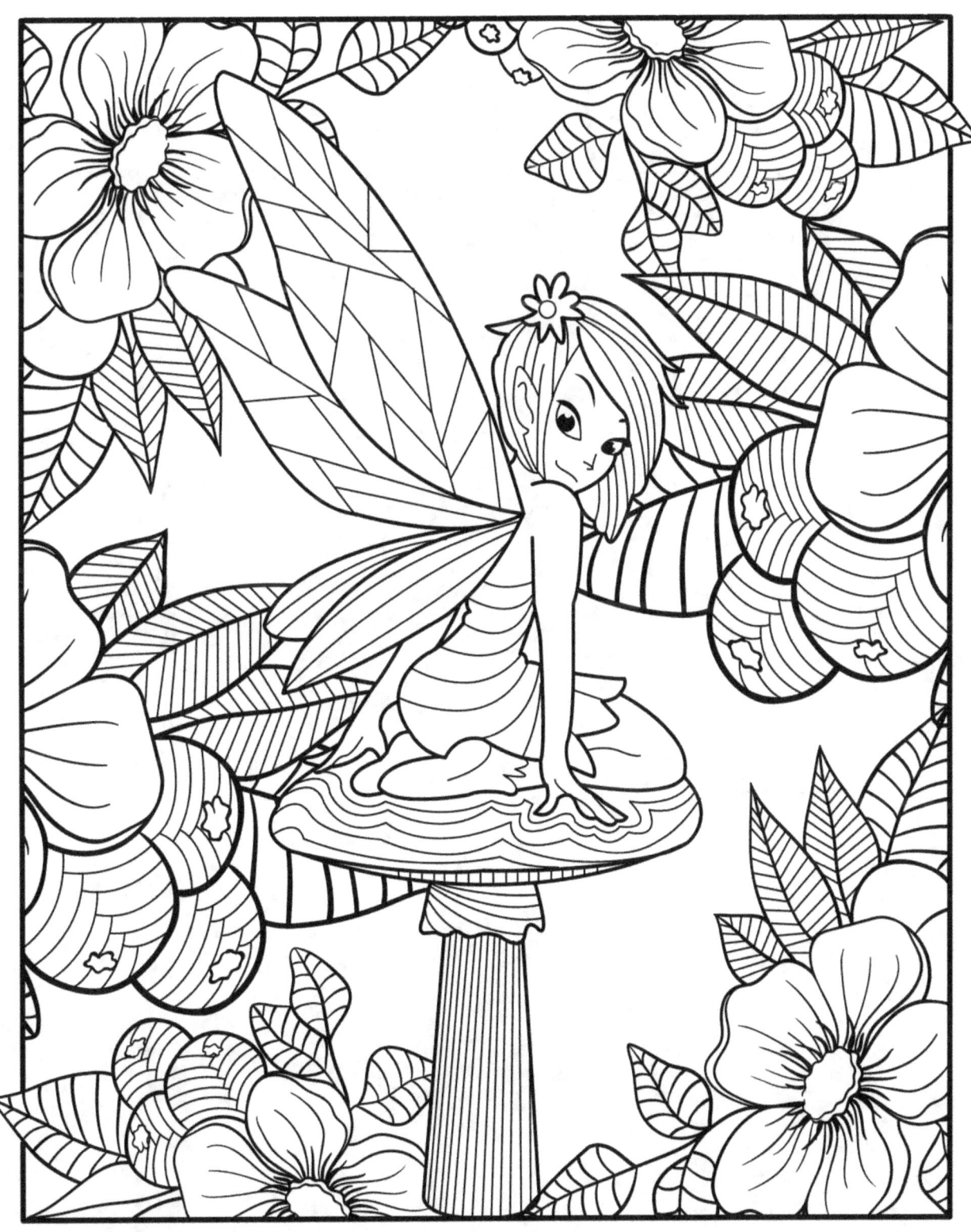

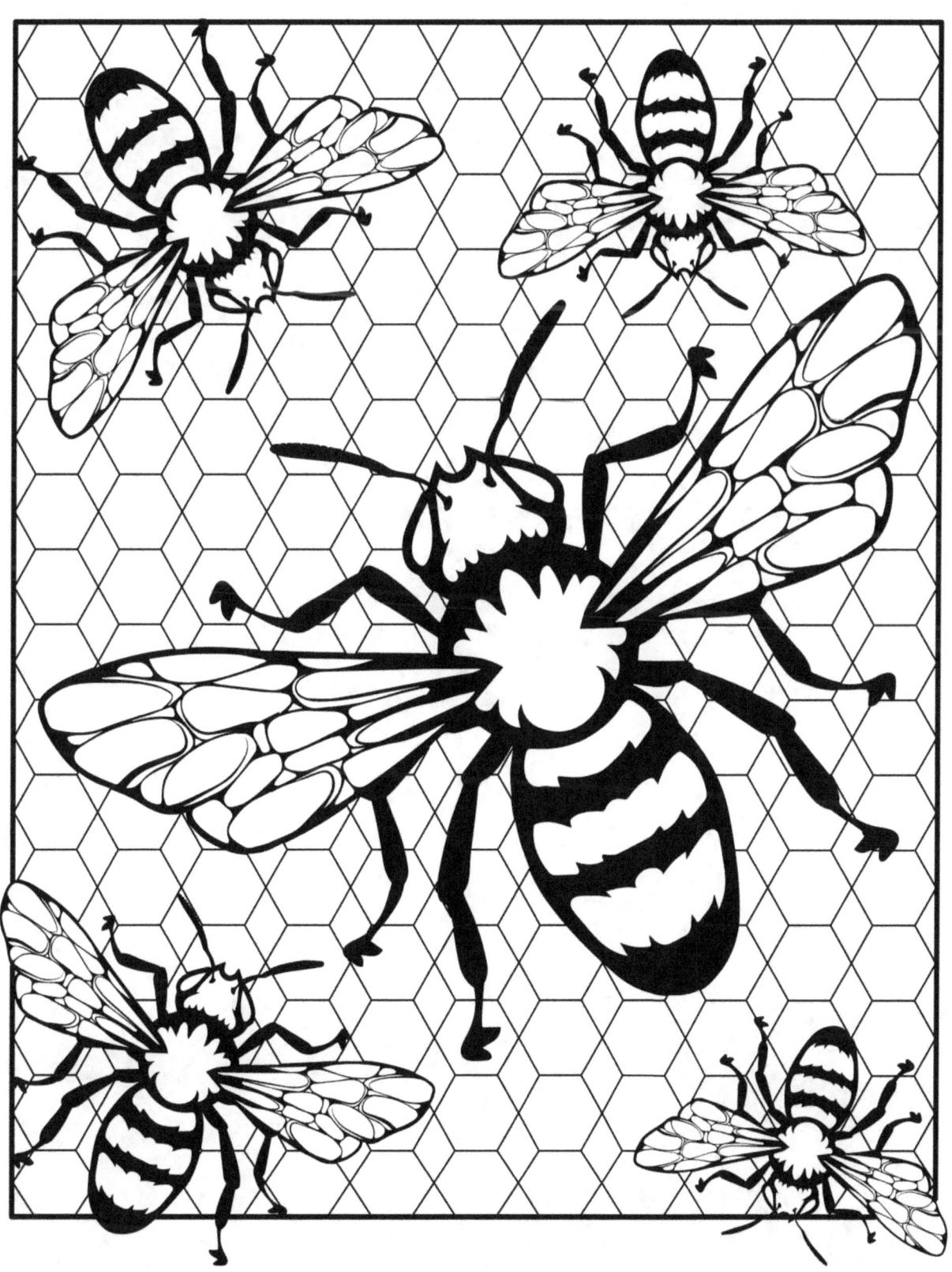

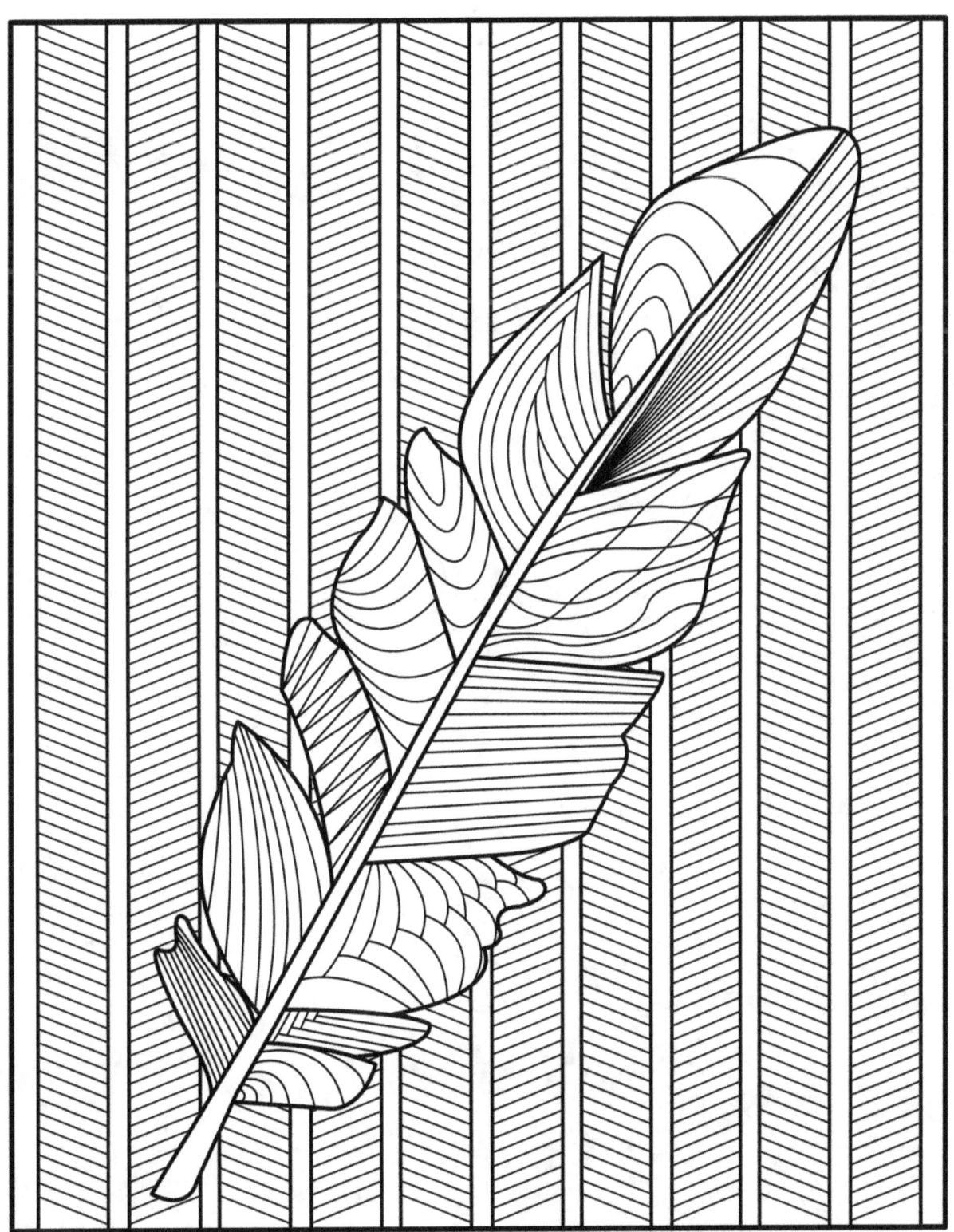

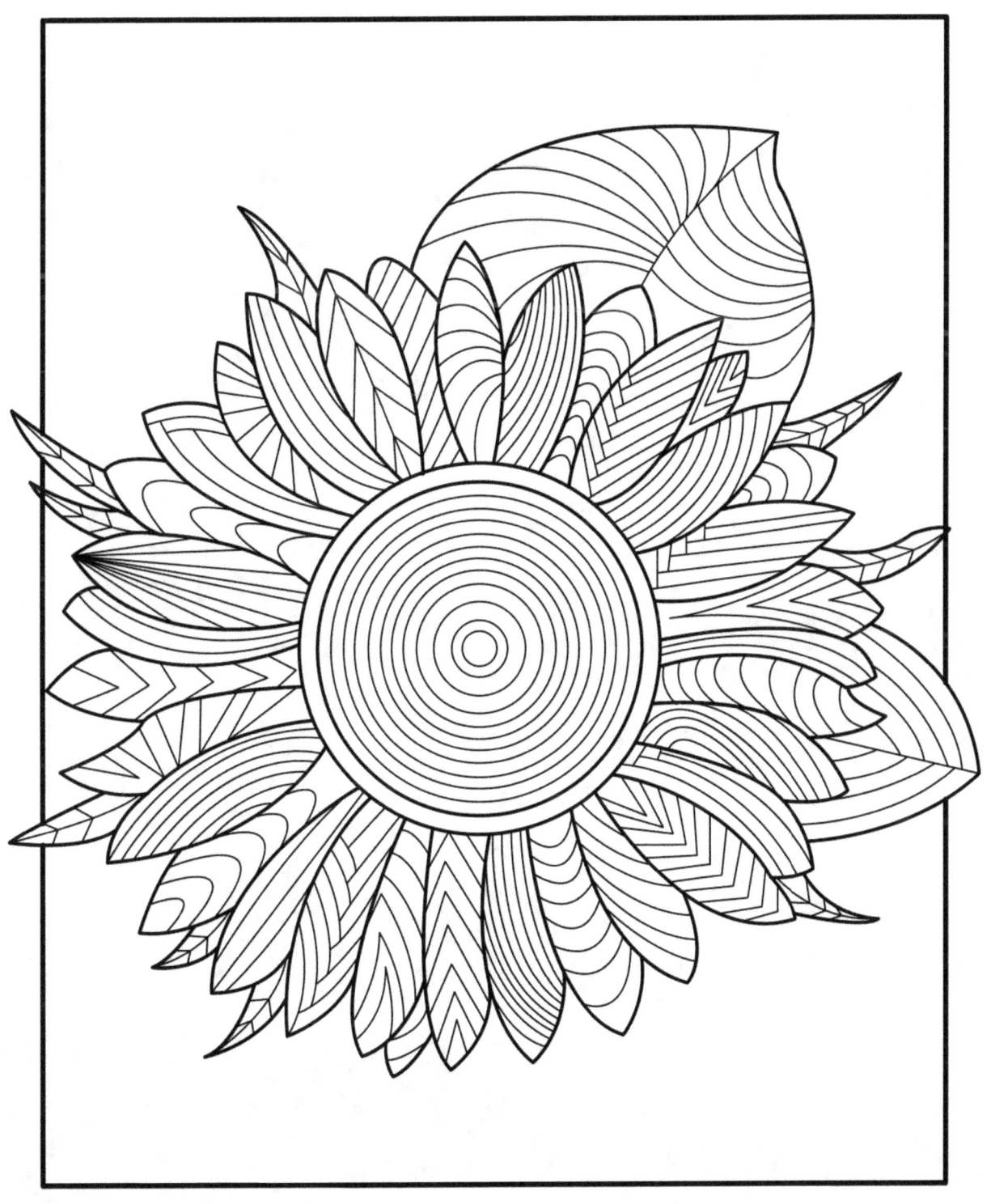

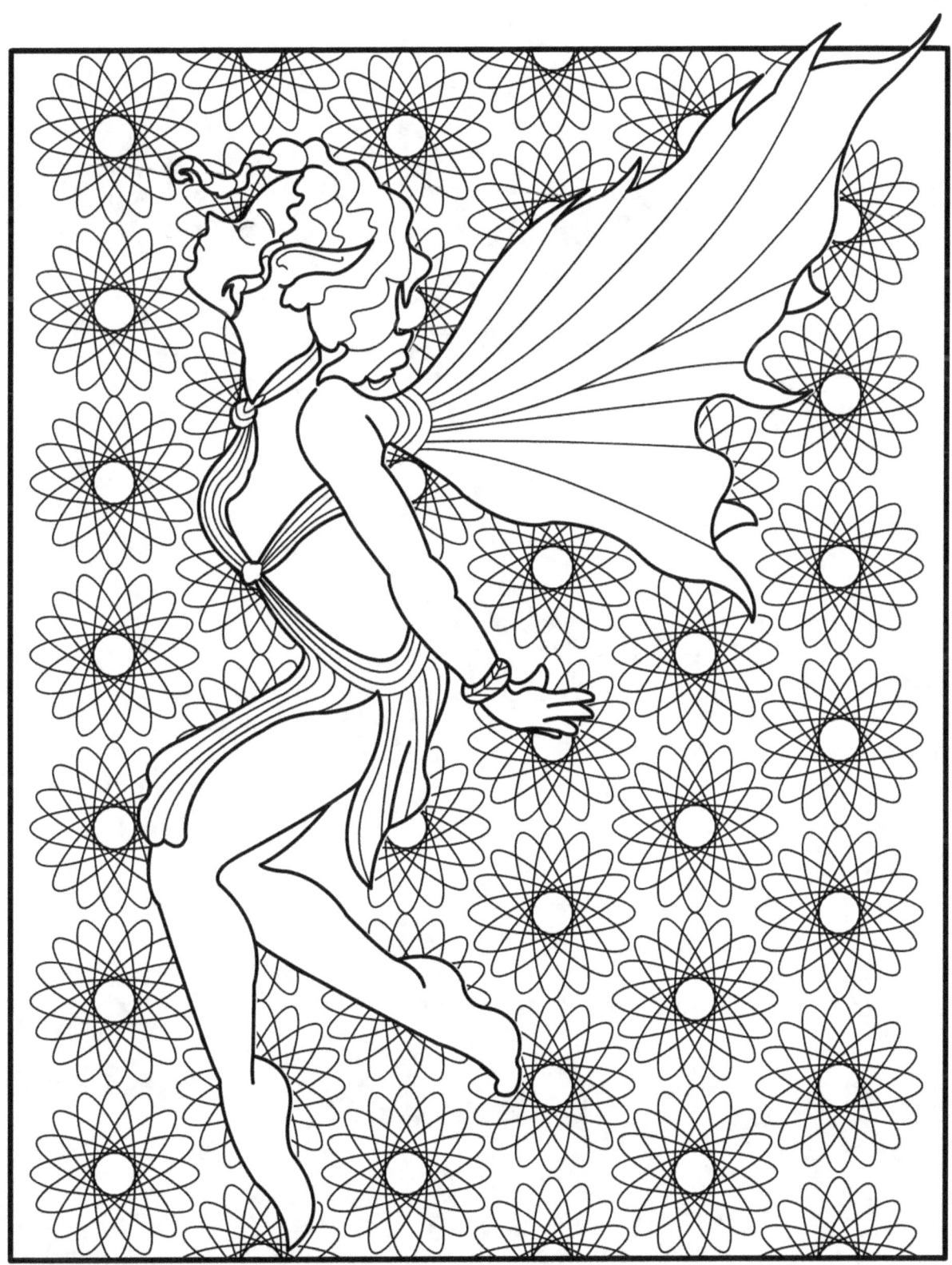

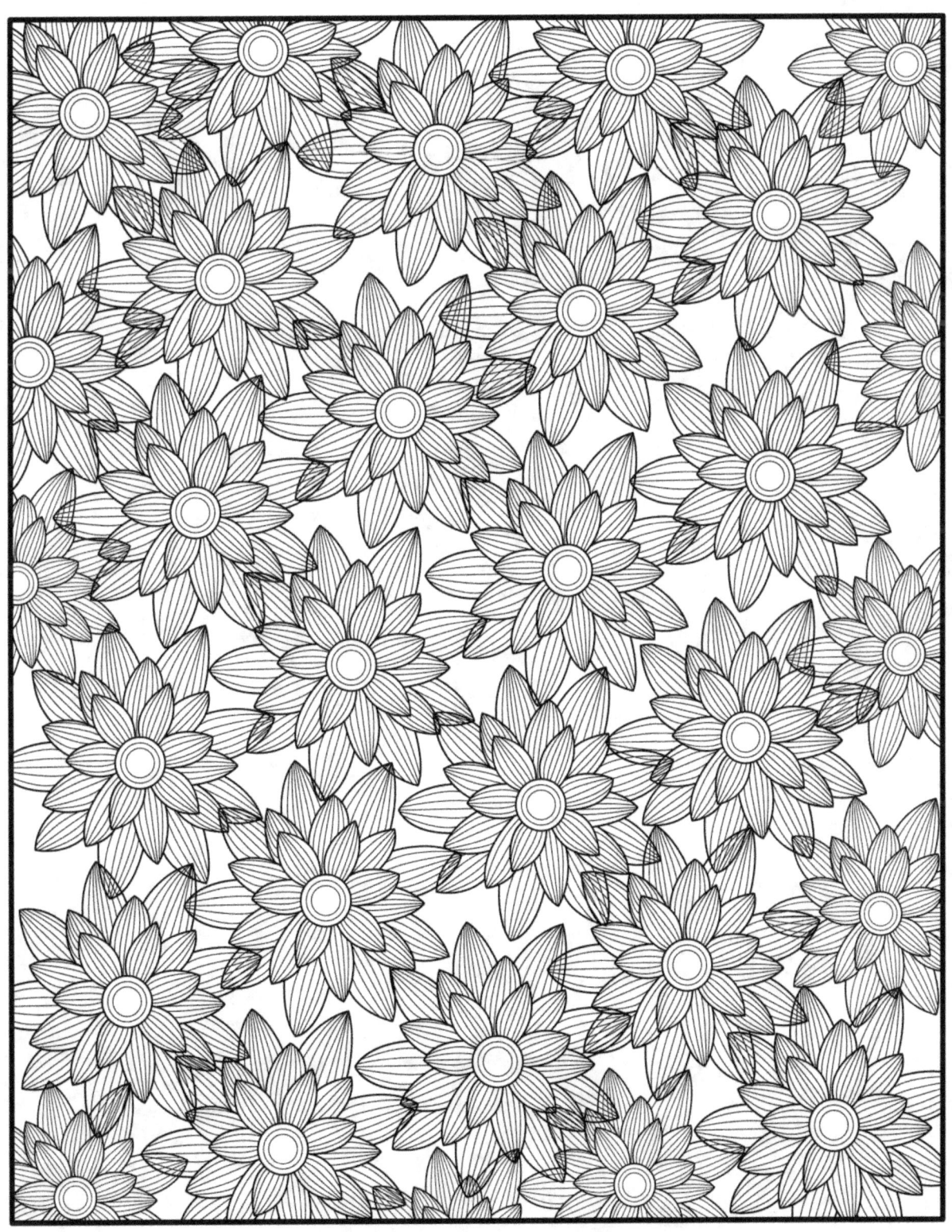

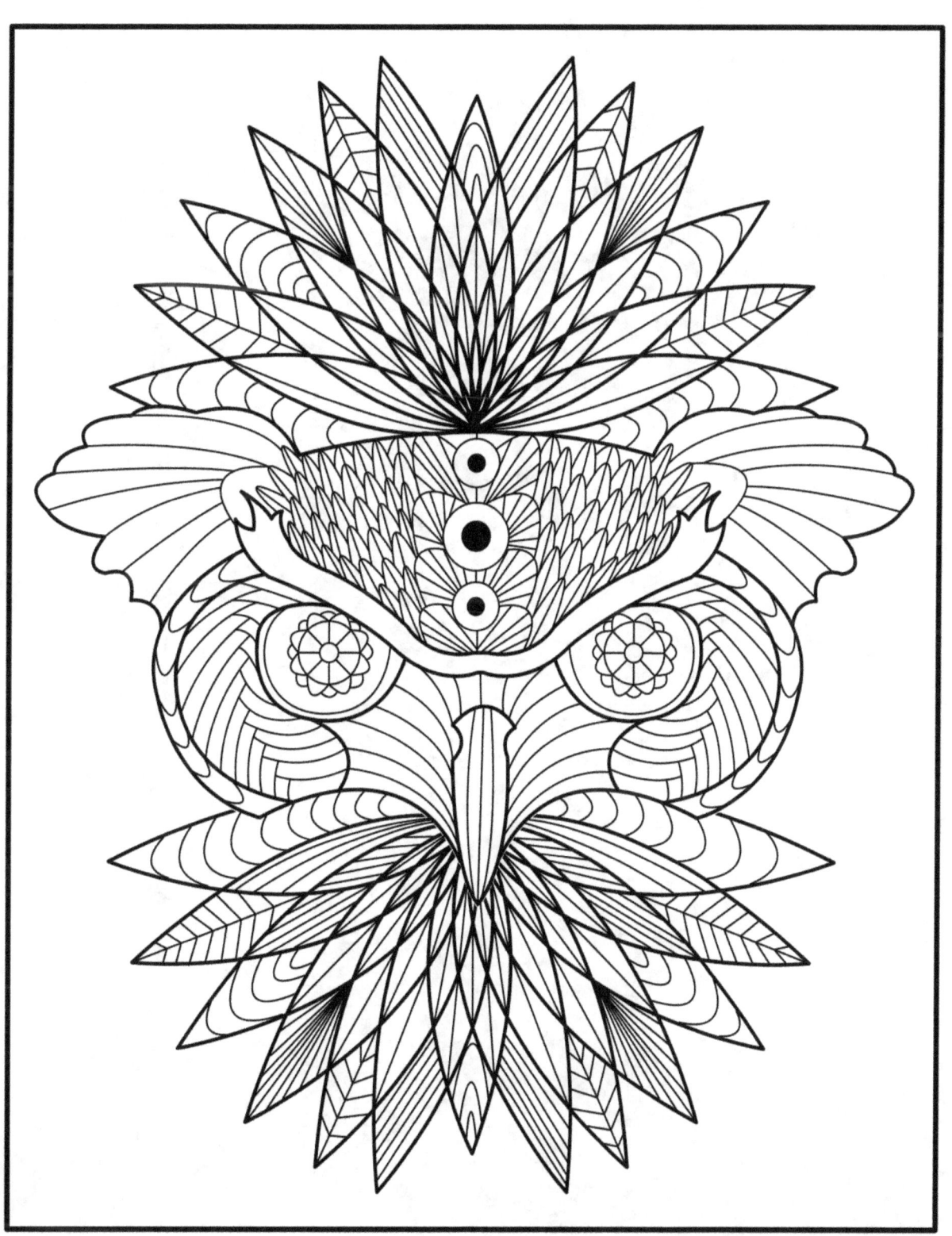

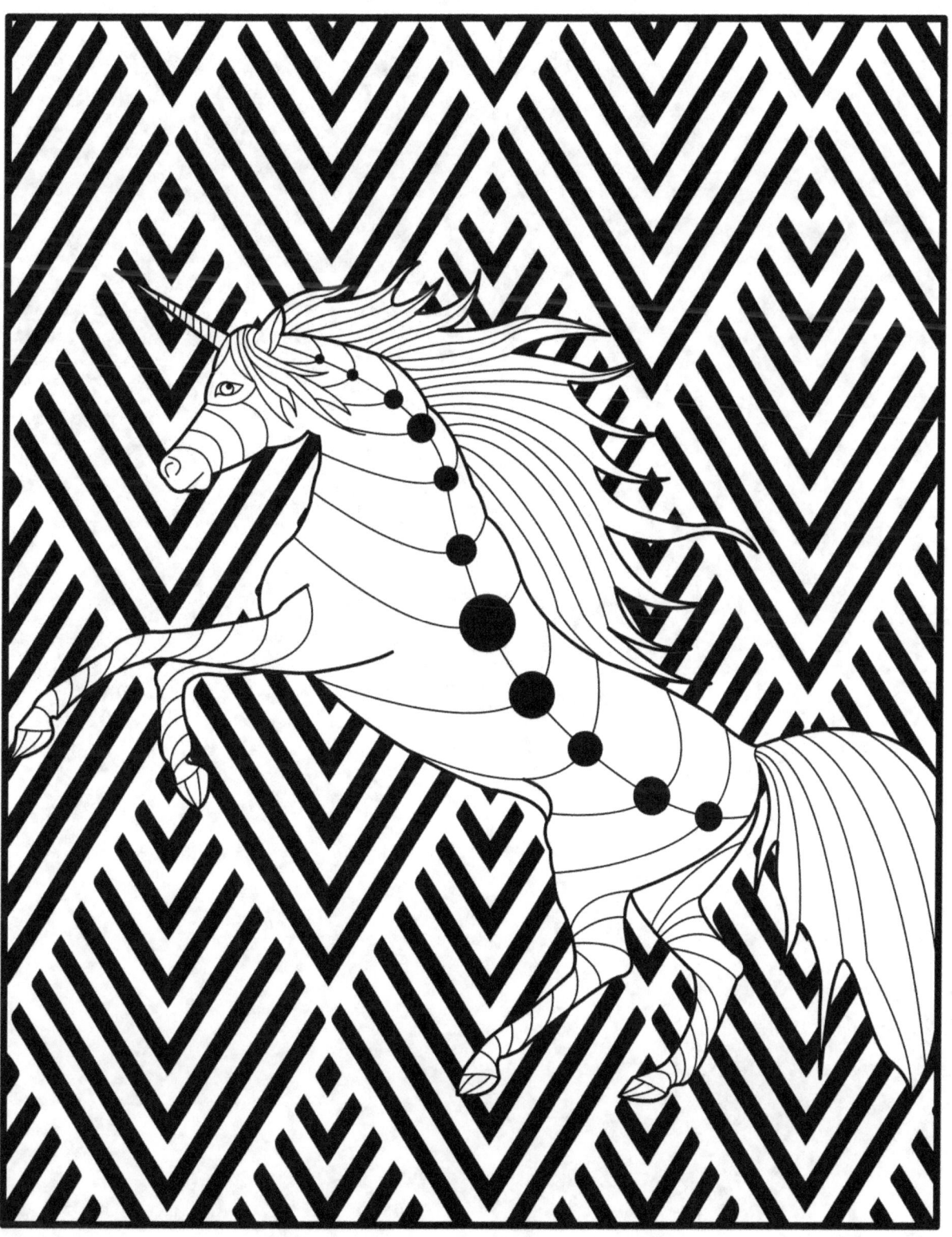

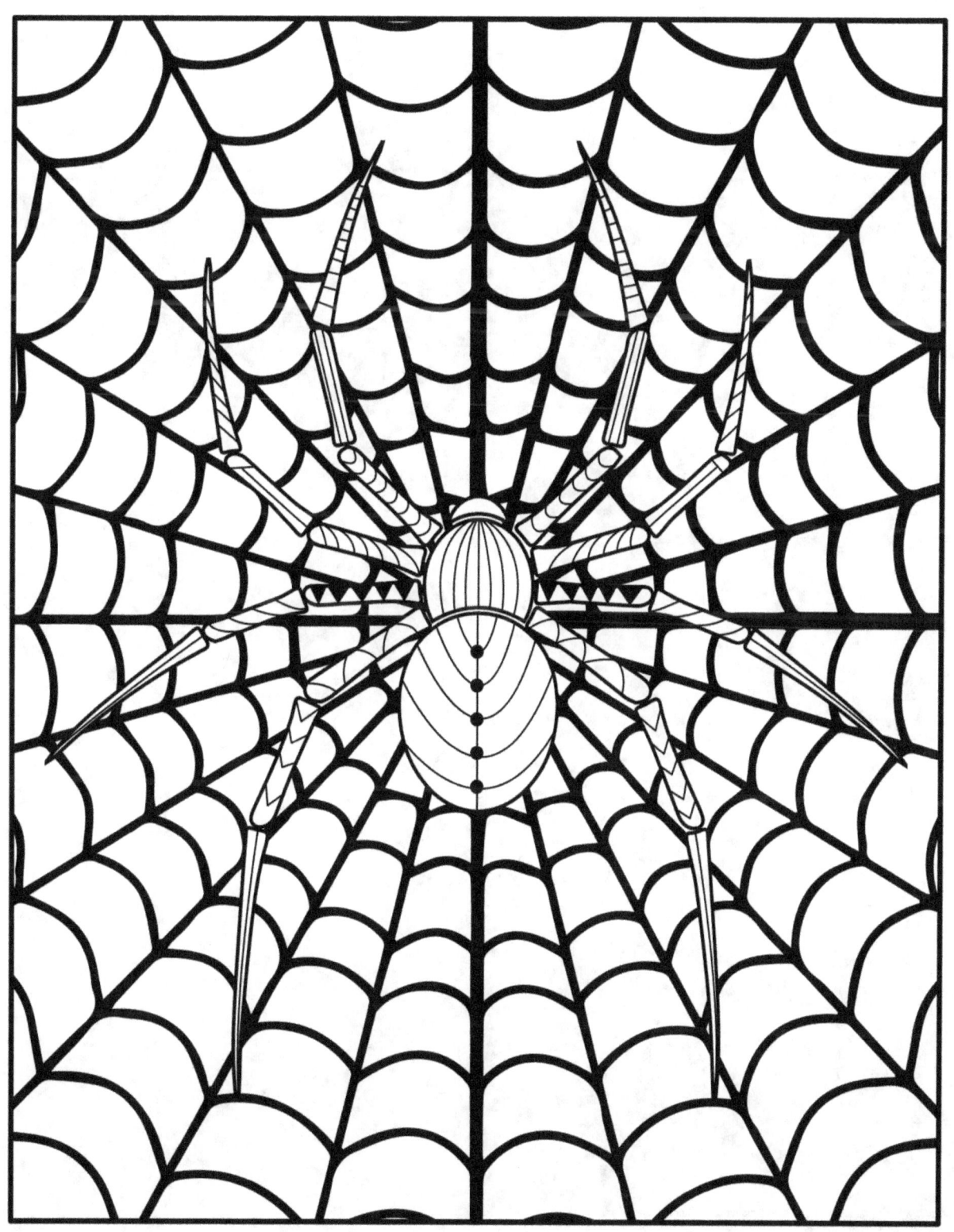

www.ingramcontent.com/pod-product-compliance
Lightning Source LLC
Chambersburg PA
CBHW081500220526
45466CB00008B/2733